Remote Exposure

Alexandre Buisse was born in Lyon, France. Growing up there meant frequent trips to the Alps, often to the Chamonix valley, which planted the seeds for his love of the mountains. Ironically, it wasn't until he moved to flat Scandinavia that, pushed by a friend, he took up climbing. He has since traveled and climbed on four continents and in most major world ranges.

Alexandre began taking a serious interest in photography in 2005 — just in time for his 20th birthday — and hasn't put his camera down ever since. His initial motivation was to record and share the wonderful views that he encountered while hiking in the French Alps and, later, on his mountaineering expeditions. Though he also shoots in urban environments, his heart decidedly lies with nature and adventure photography.

He currently lives in Denmark, where he is switching careers from academic research to full-time adventure photography; he plans to move back to France soon.

Remote
Alexandre Buisse
Exposure

A Guide to Hiking and Climbing Photography

rockynook

Alexandre Buisse (www.alexandrebuisse.org)

Editor: Gerhard Rossbach
Copyeditor: Jessica Moreland
Layout and type: Cyrill Harnischmacher
Cover design: Helmut Kraus, www.exclam.de
Printer: Golden Cup
Printed in China

ISBN 978-1-933952-65-9

1st Edition
© 2011 by Alexandre Buisse
Rocky Nook Inc.
26 West Mission Street Ste 3
Santa Barbara, CA 93101

www.rockynook.com

Library of Congress Cataloging-in-Publication Data

Buisse, Alexandre.
 Remote exposure : a guide to hiking and climbing photography / Alexandre Buisse. -- 1st ed.
 p. cm.
 ISBN 978-1-933952-65-9 (hardbound : alk. paper)
 1. High dynamic range imaging. 2. Photography--Exposure. 3. Photography--Digital techniques. 4. Mountaineering. 5. Hiking. I. Title.
 TR594.B85 2011
 778.9'9796522--dc22
 2010033785

Distributed by O'Reilly Media
1005 Gravenstein Highway North
Sebastopol, CA 95472

This book is dedicated to all the climbers I have ever been tied to,

be it with a rope, a beer, or simply a story.

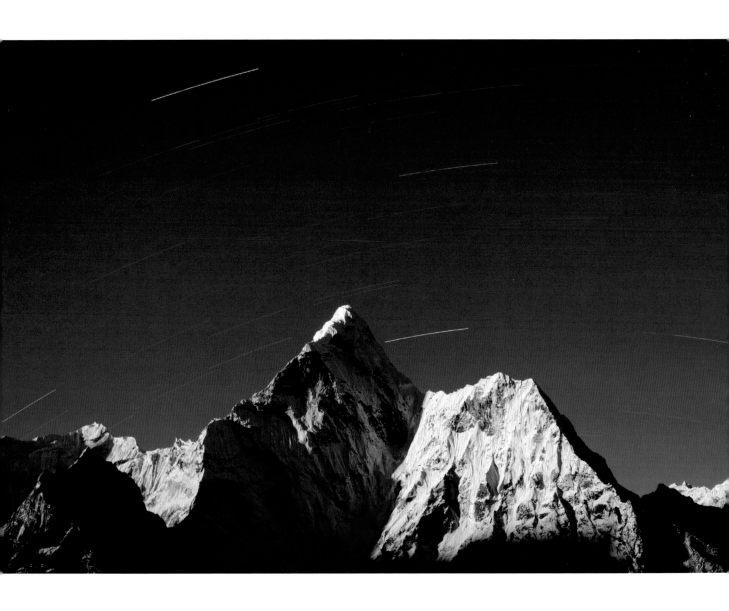

Acknowledgments

I owe a great deal of gratitude to many people for helping me put this book together.

Michael Reichmann, from *The Luminous Landscape* (www.luminous-landscape.com), was the first to give me a chance to publish what was then only a lengthy article on mountain climbing photography. The team at Rocky Nook Publishing, especially Gerhard Rossbach and Joan Dixon, then trusted me to turn that article into a book, convincing me to add hiking in its covered activities.

I have learned so much from other photographers and filmmakers that I could not possibly thank them all. Ian Parnell, Andrew Burr, Cory Richards, Paul Diffley, and Deirdre Mulcahy were all of tremendous help. In addition, and though I haven't had the chance to meet them, Galen Rowell, Jimmy Chin, Ansel Adams, Renan Ozturk, Jon Griffiths, and Cedar Wright are big influences in my work, and they continually demonstrate that photography or film is truly a grand adventure.

I have also benefited from the sharp eyes of many friends who agreed to read drafts at the various stages of writing. In particular, Samuel Thibault and Rune Bennike were incredibly helpful and read the whole thing several times. Jules Villard, Emmanuel Jeandel, Olivier Aumage, Tarik Kaced, and Thomas Ljungberg have all contributed as well.

The website reddit.com, and in particular, the users Mamoon Siddiqui and Grant, helped me find a title more amusing than just *Climbing and Hiking Photography*.

Finally, I probably owe my biggest debt to all the athletes and regular folks who keep heading into the mountains, somehow managing to bear the guy with a camera who keeps following them.

◀ *Star trails over Ama Dablam, Khumbu, Nepal. October 2010.*

Foreword

By Cory Richards

I don't know why I love the sound of a shutter so much. It's such a simple, short burst of energy, but it is so loaded with meaning. I'm still trying to figure out how such a soft sound can speak so loudly.

I've never thought of myself as a particularly talented photographer. In fact, the more I've shot, the less comfortable I've become with identifying myself as a photographer in general. As an artistic medium, photography is readily accessible to everyone, and no one's vision is any more or less valid than another's. That said, I've learned some things along the way (almost always by totally screwing something up) that have become vital in my photography.

The image creation process, reduced to its simplest form, is an easy one: move through your environment with open eyes and your gear readily accessible. The rest is up to you. I have realized however, the more I shoot, either during a sequence or during an expedition as a whole, the better the results. If you want to be the best photographer in the world, take the most pictures. Simple right? In theory: yes. But remember, it's not so easy to take photos when you are crawling from a cramped tent at 7,000 meters in the Himalaya. This advice doesn't seem so basic when your frozen fingers fumble across the camera buttons like a dog's paws across the piano keys.

In addition, take your environment into account. Not only should you be aware of it, but you should also respect it and the challenges it might bring. Anticipate what it will take to get the shot you are looking for, knowing that the climb is going to be harder for you than anyone else in your party. But remember the reward of nailing that perfect shot—so get up, get out, and get it done! Light doesn't last forever, and two minutes can make all the difference between a mediocre shot and a great one. This advice comes from a guy who has shot a lot of mediocre stuff. Trust me, the attention to detail is important, and it took me a long time to learn that lesson.

But attention to detail doesn't start and stop in the creation of a single image or photo story. You must also pay attention to a lot of other details, especially while climbing. I remember shooting rock-climber Sonnie Trotter in Majorca, Spain. After quickly building what I thought to be an adequate anchor in rapidly dying light, I dropped over the edge above the Mediterranean. Sonnie started climbing into position as I pulled out my camera. The next thing I knew, I was falling headfirst toward the lukewarm waters 50 feet below. So much for attention to detail! I forgot to pay due attention to my anchor, the one thing that was keeping me off the ground. Because I hadn't anticipated the light, disrespected the environment

I was shooting in, and rushed through an important safety check, all in an attempt to get a shot, I was hurdling headlong into shallow water. Five thousand dollars and a severely bruised ego later, I was back in business. It was a costly and dangerous lesson to learn.

Motivation to create the ideal image is a strong moving force. Forethought and meticulousness are our motivations' system of checks and balances. They are necessary.

While on your path towards creating better imagery, try to make thoroughness a goal. You must be prepared. Know the time when the light is best; have your camera in a position that is readily accessible — these are the tiny elements of my oversimplified process. I literally have a visceral response when I think of all the shots I could have nailed if I had been prepared. Being one second or one minute off became such a theme in my photography that I started driving with a camera in the seat next to me. Women were often confused when I asked them to sit in the back seat so my camera could ride shotgun.

Meticulousness, preparation, practice, awareness, and anticipation: these are the moving parts of your vehicle through this world of taking pictures. Whether photography is your job or your hobby, you'll always be happier with your productions if you felt prepared going into the shoot, and remember that spontaneity is not precluded by preparation. But you must be ready for those rare moments, those spontaneous photo opportunities, when they arise.

I could give you thousands of pieces of advice. To be honest though, you'll have more fun making the mistakes yourself. But take to heart the very basic elements of my advice, these will help you make a more educated and refined set of mistakes, rather than the dangerous and costly ones, and your images will be better from the beginning.

But back to the sound of shutter: I guess the more pictures I take, the closer I'll get to understanding what it is I love so much about that simple little sound.

Table of Contents

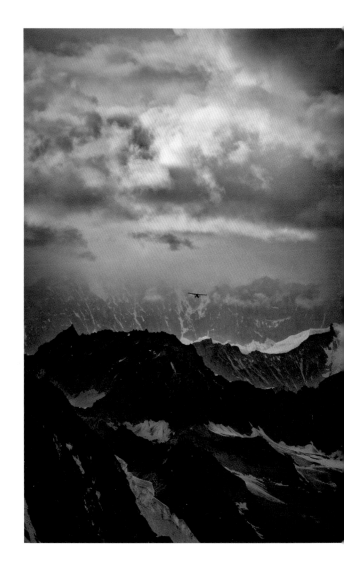

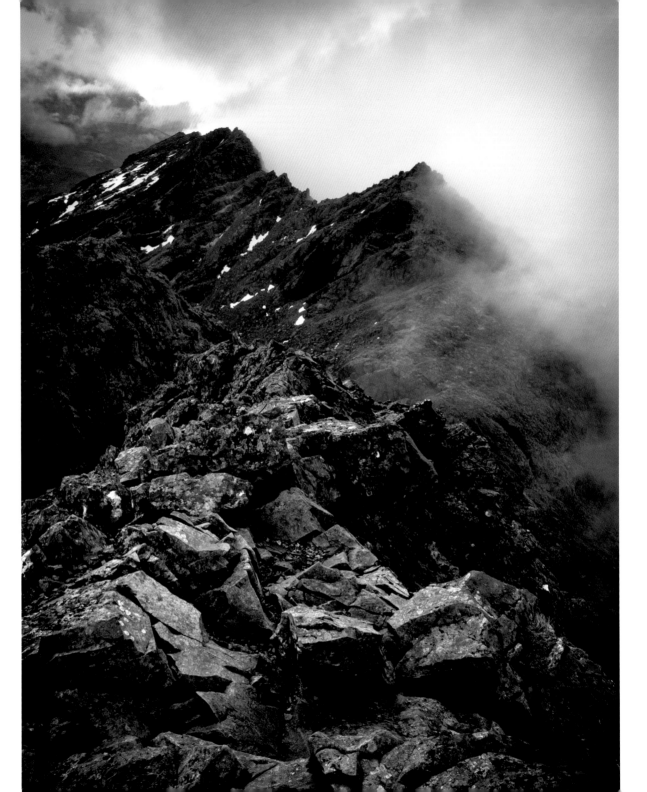

Introduction

Climbing and hiking photography is undoubtedly one of the most challenging realms of image making. At times, it may seem that every possible factor conspires to make your life harder: long approaches, terrible weather, difficult terrain, high altitude, and many others (e.g., snow glare, condensation on lenses, wind chill, or dust). The task at hand, capturing the beauty of remote environments, may appear all but impossible. Yet in spite — or maybe because — of these obstacles, mountain photography is also incredibly fulfilling. We are privileged to be allowed access to the wild places of the world and to be offered some of the most beautiful landscapes on Earth. With some effort and enough perseverance, you can master the technicalities of shooting in the mountains and become free to express your personal vision.

Who Is This Book For?

Since you are reading this book, I am assuming that you enjoy the great outdoors and its wild landscapes. Whether your preferred outdoor activity is a gentle day hike on a well-trodden path or a weeklong alpine climb, you find something deeply worthwhile in leaving behind the comforts of civilization.

◄ *A portion of the Cuillin Ridge, Isle of Skye, Scotland. May 2010.*

This book is about becoming a better photographer. I assume that you are already taking pictures while on your hikes, but that you aren't necessarily satisfied with them. You may often feel disappointed when looking at your images after the trip because, beautiful as they may be, you don't find that they adequately convey what the experience was truly like. This book will help you start — or maybe just give you a good shove — on the path toward better, and more personal, photographs in the outdoors.

One important note: I will focus on what makes mountain photography different from everyday urban photography, and I will assume that you have already mastered the basics of photography. If you don't already know about shutter speed, focal length, aperture, ISO, RAW format, etc., then you will probably find much of this book confusing. At this stage of your learning process, you might gain more from learning these basic concepts than from reading this book or any other advanced manual.

You don't need to own an expensive camera to find much of the advice presented here useful and applicable. However, a *serious* camera, such as a digital single lens reflex (DSLR) or an Electronic Viewfinder Interchangeable Lenses (EVIL), will provide the best versatility and quality. I also believe they are the most widespread types of cameras used among

the hobbyist crowd most likely to be reading this book. However, if you are shooting with a compact or a large format camera, you should find it relatively easy to adapt most of the content to your own case.

As you might have gathered from the photos and some of the stories, I am partial to mountaineering and rock climbing. However, I am also an avid hiker and was photographing long before I discovered the attractions of the vertical world. Do not worry if your interest lies only in more horizontal endeavours: with the notable exception of parts of chapter 4 "Discipline Specific", the contents of this book apply to both hiking and climbing.

Why Do We Take Pictures?

Before discussing the nuts and bolts of mountain photography, let's reflect for a minute on *why* we bother with images in the first place. After all, adding a photographic component to any trip will mean extra weight, expenses, and worry—maybe even less time to enjoy the scenery.

There are many different reasons to take pictures while hiking, and we should be aware of the ones that really motivate us. While it may be easy to take snapshots when the weather is good, the trail easy, and the camera lightweight, when conditions take a turn for the worse, your motivation will be put to the test. The strength of your determination to take the best possible image will be key in helping you overcome the various challenges that will lie in your way. Or conversely, you may realize that photography is not as important to you as enjoying the view, and you can spend less time worrying about missing that perfect shot.

▶ *One of the ubiquitous bush planes in the Alaska Range, above the Pika Glacier. August 2008.*

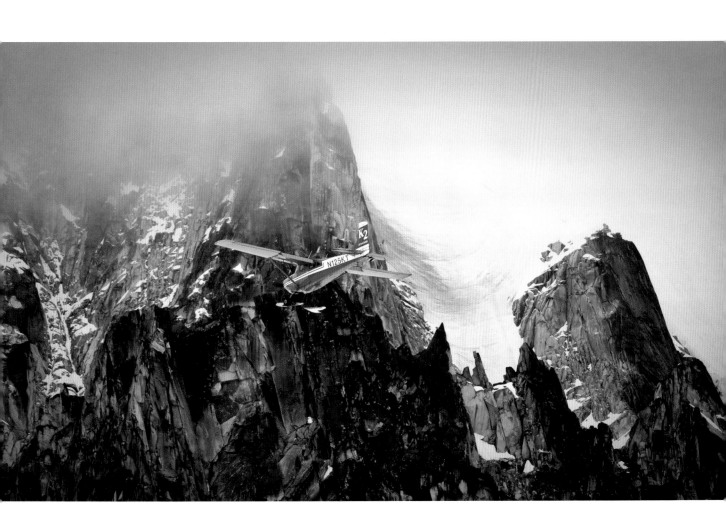

The motivation for mountain photography can fall into three main categories:

1 Photographs can be purely a witness of your presence at a specific location. The best example is the (mandatory) summit shot, proving that yes, you really stood on top of Everest. It is little different from a passport photo, and other than being sharp and correctly exposed, it requires no creativity from the operator. If this is the only type of image that interests you, take the cheapest, lightest camera available and stop reading now.

2 Another reason you might take pictures is to cement the memories of a trip for you and your companions. The main purpose of these photos is simply to help you remember your journey, and it doesn't matter much whether the photo is particularly good or not. I am sure that at some point in time we've all had to endure endless slideshows of someone who just came back from a long trip! This book, and some general photography education, will be helpful in making your images more compelling, but much of the advice here will probably be overkill for this particular application.

3 Finally, the third and most relevant motivation is to try to communicate what the trip was really like, and especially, how it made you feel. Maybe the landscapes you saw were so beautiful that you wanted to record and share them with others who were not fortunate enough to accompany you. This is the type of motivation that really interests us here and the only one strong enough to compel you to spend so much money and effort in carrying your equipment to such inconvenient places. If you recognize yourself in this description, this book was written for you.

▶ *Mountaineers after a descent from the Vallée Blanche,*
Chamonix, France. April 2009.

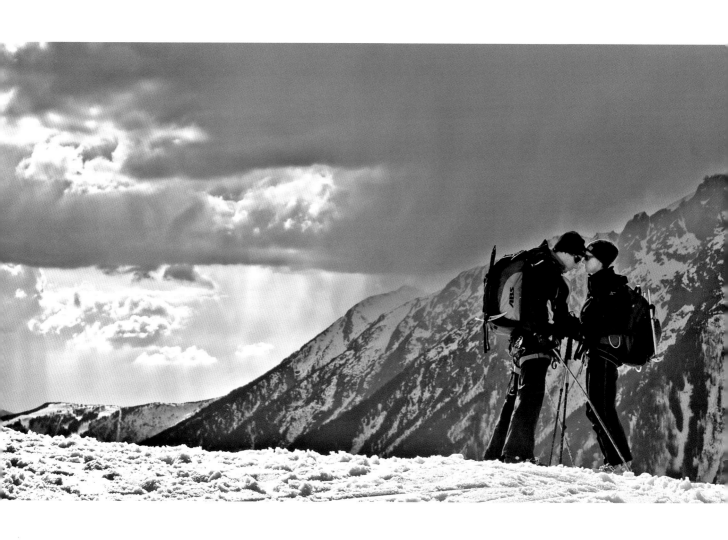

Choosing the Right Equipment

Chapter 1

There is a common saying in the photography world: "Cameras don't make pictures, photographers do." This statement is absolutely true: give the best equipment to a mediocre photographer, and he will not take significantly better pictures. Conversely, a good photographer will usually be able to obtain good images with just about any camera. Indeed, a common mistake made by amateur photographers is to agonize over the latest piece of gear, upgrading equipment whenever they are dissatisfied with the images they produce, instead of spending time learning and practicing their craft. The truth is you simply can't buy your way into creating good images.

This is only part of the picture, however, if you can forgive the pun. Equipment *does* make a difference, both in terms of what can be recorded and how an image can be used. To give some simple examples, when you shoot with the following equipment, you will encounter the following disappointments: with a low-resolution digital camera, you cannot print the results very large; with a wide-angle lens, you cannot capture the details of that faraway peak; with a slow camera, you could miss a decisive moment or a good action shot; and with a camera that does not have enough battery power or memory, you cannot take pictures at all.

In outdoor photography, having the right equipment on hand is even more important: since we invest so much time and effort in reaching the places we intend to photograph, we usually only have one chance to make the right image, and we need to be able to rely completely on our gear. Miss a shot the first time, and it's lost forever. If you make poor equipment decisions, you will have no way of photographing the wonderful scene that took you so much effort to find. On unsupported remote trips, every small detail will matter. Forgetting the extra battery might not be a big deal for a day of shooting in a big city, but it will become one if you are three days away from the closest power outlet!

Note: If filming is the main goal of the expedition, this general rule might not apply. When shooting the 1996 IMAX Everest movie, director David Breashears famously asked some of the climbers to come back down and reclimb a section of the summit ridge for a retake, at an altitude of 8500m!

Normally, the only limiting factor in making your equipment choices would be how much money you are willing to spend, but the specific constraints of photographing in the mountains introduce a new

facet of paramount importance: how much weight you are willing (and able) to carry.

Even if they have the luxury of using porters or mules, serious photographers will carry their equipment themselves, in order to have it readily available when a photo opportunity suddenly appears. If a suitcase with two pro bodies, a dozen lenses, and a pair of tripods would give you the assurance to photograph any possible situation with the optimal equipment, carrying that amount of gear never makes for a very pleasant journey. Instead, it slows everyone down and limits what ground can be covered—especially if you bring one of those annoying rolling cases! In the days of carbon fiber and lightweight alpinism, a balance between features and weight has to be struck, and you should make sure that every gram of equipment is absolutely necessary and will help you create better images.

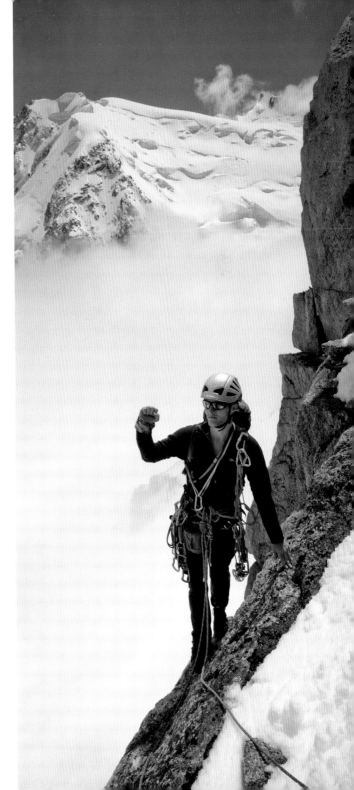

▶ *James Monypenny finishing the last pitch of the Rébuffat Route (V+, 120 m), Éperon des Cosmiques, Chamonix, France. June 2010.*

Cameras

The first and most obvious choice in front of you is deciding which camera you will take on the trip. Since it will influence many other decisions, I suggest reviewing the various options first.

Working With Film

Despite what photography magazines may say, film is not completely dead, and analog photography has not yet entirely been replaced by digital.

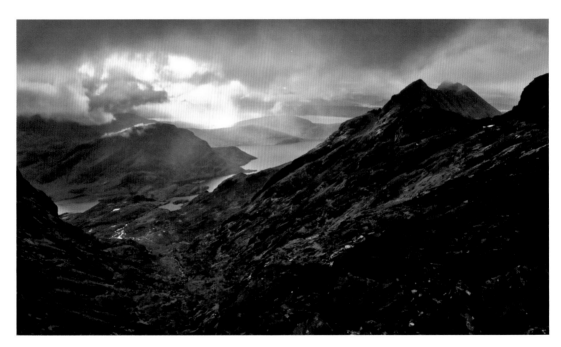

▲ *This was shot on a super lightweight solo 1-day attempt on the Cuillin Ridge of Skye. I had compromised climbing equipment to the point of abseiling on a 6mm line with a sling harness, so carrying a DSLR wouldn't have made much sense. DMD cameras like the Olympus Pen used here are perfect for this kind of application. (The Cuillin Ridge, Isle of Skye, Scotland. May 2010.)*

Because of its reliability, a manual film SLR is still a popular camera choice for a remote expedition.

The main reason for such a choice would be that old manual SLRs, as well as most rangefinders, possess a mechanical shutter system that can operate without any power source. Some cameras have tiny batteries required only for metering and may last years without needing to be replaced. Should even

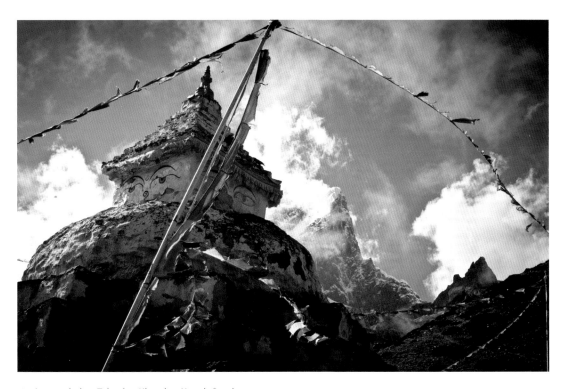

▲ *A stupa below Taboche, Khumbu, Nepal. October 2010.*

these fail, you can take pictures by guessing exposure information. In addition, these cameras tend to have extremely sturdy metal bodies and are, generally speaking, much more reliable in all kinds of extreme conditions. Generations of photojournalists can attest to the resilience of the Leica M series or the Nikon FM, and most of these cameras are happily snapping photos decades after leaving the factory!

The downsides to film cameras, however, are many. One of the most obvious drawbacks is that without the ability to instantly review results on the rear LCD screen, errors are easier to make and harder to correct. Furthermore, photographers need to be a lot more experienced in order to operate these cameras correctly. Many of the automatic features we have come to rely on are missing, such as autofocus or even metering in some cases. For instance, it takes a lot of trial and error to find out exactly how the combination of the meter, lens, and film emulsion react to the presence of snow, a notoriously difficult subject to expose properly. If you are interested in this kind of camera, you can take the time to learn how to use one, but it is a long process, and you will not be able to bring back all the images you missed while learning.

Another issue with film cameras lies in the physical medium of film, as opposed to the immaterial storage of memory cards. Each image has a fixed cost, and when you start taking hundreds, or perhaps even thousands, of photos on your long trips, your overall expenses can increase quickly. This high cost will also tend to reduce the overall number of frames you take, thus limiting experimentation and, in the long run, causing you to miss some opportunities. (See chapter 3 under the section "Quantity vs. Quality" for more on why I think taking as many pictures as possible may be a good thing.)

Film rolls are much harder to manage than digital memory cards, and they weigh a lot. Before leaving on your expedition, you will need to guess how many images you will be taking on the whole trip, a crucial process during which any underestimation will prove catastrophic. You also cannot backup images before returning home, so if you drop or lose the roll with your award-winning images, they are gone forever. Film is also physically harder to manipulate, gets brittle with cold, and can even break inside the camera. Changing rolls can be difficult, especially with gloves on, and Murphy's Law guarantees that the best photo opportunity always happens after image 35.

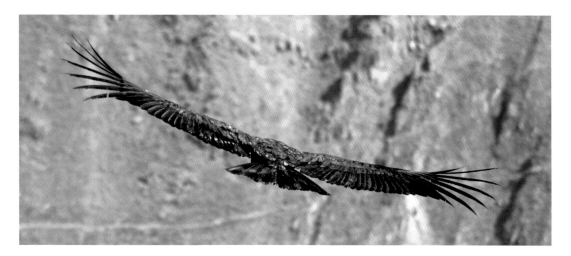

▲ *Andean Condor in the Colca Canyon, Peru. October 2007.*

Finally, digital cameras provide some technical advantages. Film has a fixed sensitivity (ISO), which means that it is harder to adapt to different light conditions, and again, you need to guess beforehand what the conditions are likely to be. Though negatives are still slightly ahead of the best digital sensors, the more commonly used color slides have a much smaller dynamic range, and you can't use HDR (exposure stacking) on traditional film. Without using neutral density grad filters, you may have difficultly recording scenes with high contrast, a very common occurrence in the mountains. Since most parameters are fixed at the time of capture, you will most likely need to use filters, such as neutral density, white balance, or polarizer filters. They are an additional expense, as well as extra equipment to carry and take care of.

For all of these reasons, I wouldn't advise using a film camera as a main system on an expedition. But, weight allowing, a light rangefinder or mechanical SLR with a couple of rolls can be a great backup in case the fancy digital camera decides to stop working on day two. Just make sure you remember how to shoot film!

Compact Cameras

Compact digital cameras (also called point-and-shoot or P&S cameras) are a big compromise in favor of their low weight, easy portability, and low price. Though their portability and apparent simplicity make them attractive for the outdoors, they have such severe limitations that they should be avoided in most cases, at least as a main system. While it is true that under ideal conditions they may produce images rivaling medium format digital backs costing upward of $20,000, these results only occur in well-lit scenes of static subjects at an average distance.

Some of their disadvantages include heavy noise (even at moderate ISO speeds), low battery life, slow autofocus, shutter lag, and non-interchangeable lenses of often disappointing quality. Many of these cameras do not offer a viewfinder, using the LCD screen instead for composition, which leads both to great framing difficulties in direct sunlight (especially when snow and sunglasses are involved) and to increased power consumption. Finally, all but the most expensive models offer little manual control and no possibility of shooting in RAW format, relying instead on JPEG and dumbed-down program modes, forcing photographers to spend as much effort working around the quirks of the camera as they do on composing the images.

▲ *Martin Breed on top of a boulder problem, Lysekil, Sweden. July 2008.*

In my opinion, compact cameras should be considered as a main system in only two cases: either when the climb is very difficult and having an extremely light weight camera is more important than bringing back good images, or when the only role

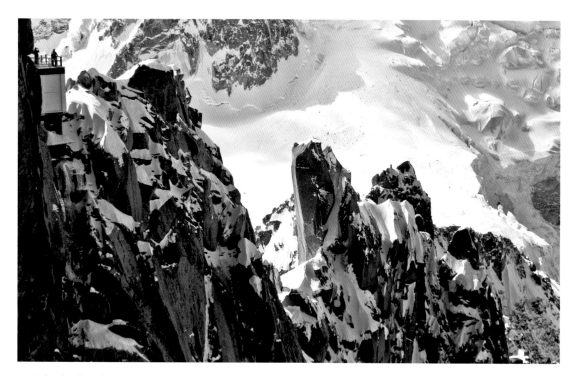

▲ *Arête des Cosmiques, Chamonix, France. April 2009.*

of photography on your trip is to take snapshots to complement your personal memories.

That said, a high-end compact could serve as a useful backup in case of the catastrophic failure of the main camera, and its low weight and small size mean that you are more likely to carry it with you at all times, thus capturing pictures at unlikely times, for instance on the approach or in cities. However, when things get serious, you should have a camera that will allow you to get the best results with minimal fuss: either a DSLR or an EVIL camera.

DSLRs

Digital single-lens reflex cameras are much heavier and bulkier than compact cameras, or even their film counterparts, but they offer a tremendous increase in versatility, user control, image quality, and reliability. In my opinion, a mid-level DSLR represents the best compromise between features and portability, and it will allow you to bring back better images than any other system. Anything smaller will mean the loss of important capabilities, limiting which photos can be taken, and anything bigger will be cumbersome, meaning you will be less likely to shoot.

Here are some of the important characteristics of a DSLR:

- Even the smallest DSLR sensors (known as APS-C, DX, or simply cropped sensors) are physically larger than the ones found in compact cameras. Though the results of the larger sensor are difficult to quantify, the images produced are usually of a better quality, especially at high ISO, opening lots of possibilities for low-light shooting without a tripod. Large sensors also allow for a shallower depth of field, an important compositional tool for focusing the attention of the viewer on the subject.
- DSLR systems are modular and lenses are interchangeable. This is an extremely important attribute because it makes the camera infinitely more versatile. (See the next section for a more complete discussion of lenses.)
- Even though the live view function (a framing tool that shows the subject on the LCD screen) is now widespread, the optical viewfinder is the primary framing tool on all DSLRs, and this system is kinder to the battery and is possible to use even under direct sunlight. My personal and unquantifiable belief is that an optical viewfinder offers a more pleasurable shooting experience, which will lead you to take more and better images (and enjoy the process)!
- Battery life is generally longer on digital cameras than on compact cameras, and you can often find precise information about the remaining charge, a very important parameter for long trips without external power.
- The cameras tend to be faster, both to focus and to expose, removing the annoying shutter lag of compacts. High burst rates also give you more chances to capture that perfect moment within an action sequence.
- Most cameras have some form of auto-bracketing capability, allowing you to automatically take three pictures with various exposure values, a crucial tool for HDR photography. (See chapter 5 for more on this topic.)

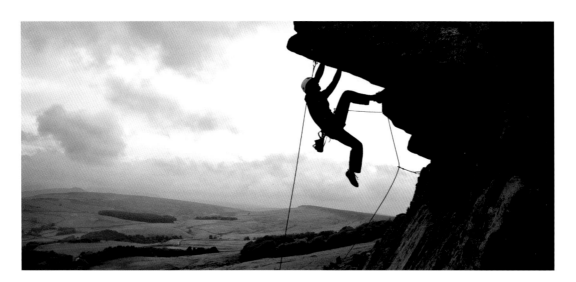

▲ *Rune Bennike on Flying Buttress Direct (E1 5b), Stanage, England. June 2010.*

There is an array of classes of DSLRs, from entry-level to professional bodies, with prices varying from a factor of 1 to 10. However, given enough time, the technological advances of the best cameras will usually trickle down to more affordable models. The main differences between the ranges lie in the features and general robustness of the body, with the added side effect that the professional cameras are bulkier and heavier than the others. You can often find a good compromise in terms of weight, features, and price in the so-called prosumer bodies, which usually lie in the middle of the camera lines. For instance, in 2010, these would be the Nikon D7000 or D300s, and the Canon 50D or 7D.

◄ *The Nikon D90, my current camera of choice.*

Electonic Viewfinder Interchangeable Lens Cameras

For years, photographers have requested a new class of digital cameras halfway between compacts and DSLRs, putting a high quality sensor and interchangeable lenses in a small and light mirrorless body. However, the first viable models didn't appear until 2009 from makers such as Olympus (Pen series), Panasonic (G series), and Sony (NEX series). They are what photographer/blogger Michael Johnston has been calling the "decisive moment digital" and that, for lack of a standard acronym, we will call electronic viewfinder, interchangeable lenses (EVIL) cameras, following Nikon in the matter.

Though they are primarily designed for street photography, the combination of advanced features, high image quality, and low weight seem to make them ideal candidates for hiking and climbing photography. They certainly deliver an image quality very close to APS-C DSLRs (with consumer lenses) and are a pleasure to carry in the mountains, but they also have some drawbacks.

First of all, in my opinion, the absence of an optical viewfinder is a shortcoming, as no LCD or electronic viewfinder (EVF) can beat the resolution or color rendition of an actual through-the-lens optical path. With snow reflections on sunny days, the lack of a view-

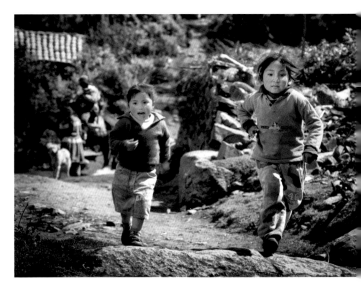

▲ *Peruvian kids in the Santa Cruz valley, Cordillera Blanca, Peru. June 2009.*

finder makes it nearly impossible to frame accurately. Second, their battery life, though more impressive than that of compacts, can't rival a DSLR's, simply because of their size and heavy LCD screen usage. Finally, the range of dedicated lenses is still quite limited, forcing one to make some compromises and limiting the use of exotic or professional optics.

When comparing similarly priced cameras, whether you prefer an EVIL or a DSLR will be an entirely personal choice. Your decision will come down to the trade-off between weight and some special features and more choices in lenses. Certainly, both systems are extremely capable and unlikely to limit you creatively.

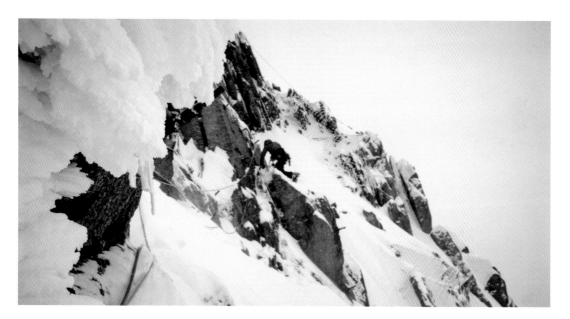

▲ *James Monypenny below the central piton of Aiguille du Midi, Chamonix, France. June 2010.*

Olympus kindly lent me a Pen E-P1 with a kit lens to test during the winter and spring of 2010. I initially hoped it could replace my DSLR system entirely, but I soon realized that I was missing something—the direct feedback and pleasure of seeing the photo through a viewfinder. Having learned photography with a Nikon meant that I was reluctant to frame with an LCD, and after a while, I started carrying my DSLR again. The Pen has a place in my system though: for *really low-weight climbs or on trips during which I don't plan on taking many photos, I happily carry this small camera.*

◀ *Olympus E-P1 with 17mm lense*

The Big Stuff

One last class of cameras remains: the exotic bodies that make no compromise on image quality or features but pay the price with extreme bulk and weight. This class would include pro DSLR bodies with integrated grip and digital backs, and medium and large format cameras.

In most cases, it would be a bad idea to bring these systems on anything other than short trips that do not venture far from the car. Though the results can indeed be of superior quality than with the other options, carrying the camera, as well as setting up a shot, can become such a hassle that it would become too easy to forego the shot and simply keep walking. It is important to keep in mind that a less than perfect image is still better than no image at all.

The photographer also needs to be aware that using such cameras will only provide better results if flawless technique is used at each and every step of the image-making process. This means using the best lenses, acquiring a heavy tripod with a high quality ballhead, mirror locking, perfecting exposure, printing a large copy on high quality paper, and a myriad of other considerations. If any of those steps is overlooked, the final image will likely be no better than what a regular DSLR could have produced.

In other words, choosing such a system will be no guarantee of bringing back better images, but it will certainly make you bring back fewer photos! So unless you have a very good reason to choose something of this nature, and you know your equipment inside out, and you have mastered optimal shooting techniques, I wouldn't advise you to bring a big camera on a remote hike or climb.

Back in 2008, lured by the promises of gigantic prints and infinite depth of field, I decided to use a 4x5 view camera. Initially, everything was fine, and I had fun recording some urban landscapes in Copenhagen, Denmark. But as spring approached and trips started lining up, I realized that, even on short hikes, I was always making excuses for not bringing the 11 pounds' worth of equipment. And if I happened to take the camera, I would only go through the hassle of setting up the tripod, metering, adjusting movements, calculating reciprocity, etc. when the scene in front of me was absolutely perfect and the conditions most convenient.

After a six-month period, I realized that I shot less than 20 images and that almost all of them were captured at less than a hundred meters from my home or my hotel. Sadly, I then sold all of my large format equipment.

▶ *Moonrise over the Aiguille de Blaitière, Chamonix, France. April 2009.*

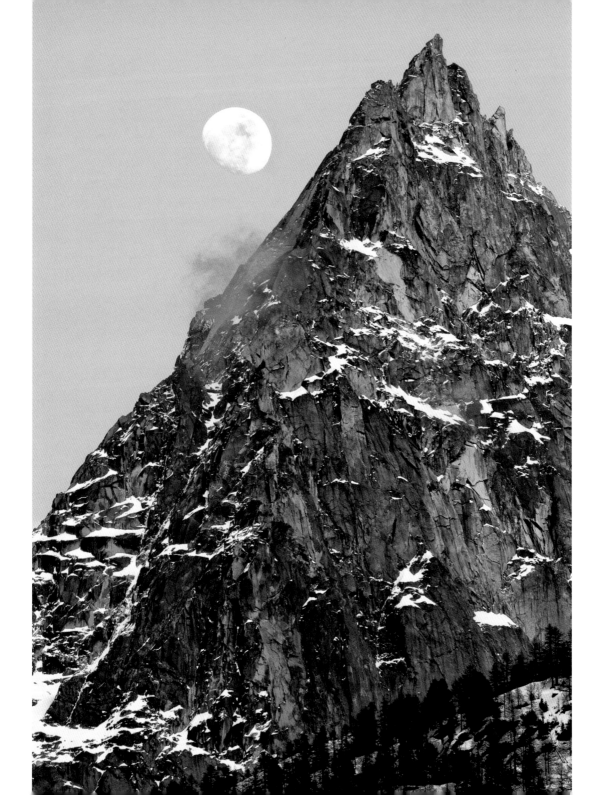

Lenses

Once all the gimmicks are removed, a camera body is little more than a light-tight box helping project light on a photosensitive surface, be it film or a digital sensor. At least as important to the final image, however, is the piece of glass that will transform the scattered light rays of the outside world into a coherent beam: in other words, the lens.

Assuming that your system allows interchangeable optics, choosing which lens to take on a trip is every bit as difficult and important as choosing the right camera. As mentioned before, you need to balance versatility and features with weight and portability, as the best optics will also often be the heaviest ones. Another thing to consider is that using multiple lenses means you will have to switch them in the field. While this is generally a straightforward operation, it can become a lot more challenging in a sandstorm or with your mittens on.

The one piece of good news, though, is that in the mountains, you don't have to worry too much about fast lenses (those with large apertures and small f/stop numbers of f/2.8 or less), since you will rarely shoot in light conditions low enough that it justifies the increase in price and weight.

Note: Whenever discussing focal lengths, I will assume that you are using a 1.5x APS-C format DSLR. If you are using another system, you may need to multiply by a fixed coefficient to find an equivalent angle of view. For instance, FX users should multiply by 1.5, so that a 16mm lens on a Nikon DX has the same angle of view as a 24mm on an FX.

Workhorse Zoom

I believe that every photographer should have some sort of *default* lens that stays more or less permanently on the camera, one you can always rely on if you are unable to use other optics for some reason (e.g., because you left them at base camp or simply because it would be inconvenient to change lenses). Depending on your subject matter and your personal vision, your default lens choice may vary, but a wide lens is generally going to be the most useful, both

▷ *AF-S DX NIKKOR 18-55mm f3.5-5.6G VR*

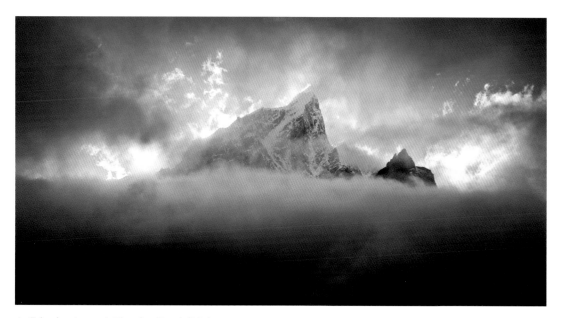

▲ *Taboche at sunset, Khumbu, Nepal. October 2010.*

for capturing landscapes and for showing climbers or hikers in their environment. Many manufacturers produce inexpensive and light-weight zoom lenses from 18 mm to somewhere between 50 and 200 mm, and these are good default choices.

Since you will probably use this lens at its wide end most of the time, you should think carefully about whether the extra reach of longer focal lengths is worth the extra price and weight (and sometimes the loss of image quality). In some cases, kit lenses of entry-level DSLRs, such as the Nikkor 18-55mm f/3.5-5.6 can give better results than trans-standard zooms like the Nikkor 18-200mm f/3.5-5.6. Also, image stabilization (called VR, IS, or OS depending on the brand) technology is becoming more widespread and is now integrated in most zooms (even at those wide focal lengths) making large apertures even less relevant.

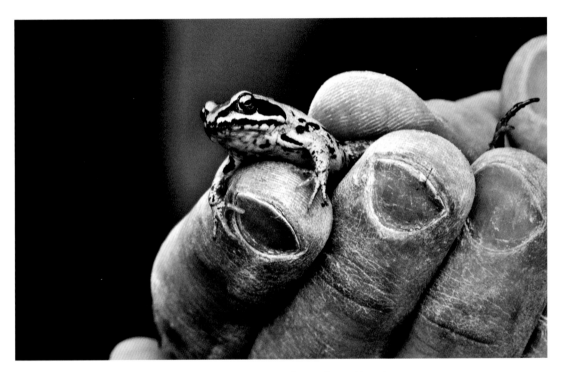

▲ *I initially despaired that I didn't have a macro lens to shoot this, but after stepping back and using my long lens, I realized that I had obtained a unique perspective instead of yet another repeat of the same image. This tiny frog was released unharmed moments later. (Uppsala, Sweden. April 2006.)*

Some Extra Reach

Almost as useful as wide angle, telephoto lenses are often a necessity for capturing landscapes adequately, as well as for closing in on other hikers from a distance. Oftentimes, the interesting parts of a scene, such as the clouds on a mountaintop or the climbers on an icefall, will be too far away to be captured correctly with a standard zoom, and you will then need to

switch to the big glass. A telephoto even allows you to take some (modest) wildlife images when the opportunity arises.

A 200 mm lens should be enough for almost any situation, especially considering that you will be shooting without a tripod most of the time. It is rarely necessary to use the best professional lenses, as their main concern is to be very fast (i.e., they have large apertures) for indoor or low-light use. The best options are by far lightweight telezooms, such as the Nikkor 70-300mm f/4.5-5.6 VR or the Canon 70-200mm f/4L.

Any of those options will make a great second lens for any hiker and climber's kit, though you also need to be aware that they will likely be the first to stay in camp when you decide to go light.

Ultra Wide

Zoom lenses wider than 18 mm offer photographers an intriguing perspective and can often create drama and heighten the interest in an image. They are especially useful in technical climbing because they emphasize verticality and the portrayal of height, though they only work well if you take the trouble to ascend technical pitches ahead of the main party. (For more information on this issue, see chapter 4 in the section "Technical Climbing.")

Though popular for landscape work, ultra wide lenses can be surprisingly tricky to use. A common misconception is that they are useful to "put more in the frame," but when used in this way, they produce flat and disappointing results. This type of lens really shines when used to add depth to an image by showing interesting subjects at various distances. A classic landscape example would be a flower in the foreground, a lake in the middle ground, and a snowy peak in the background.

In my experience, ultra wide lenses tend to remain specialty items among most climbing photographers and are generally used less frequently than normal and telephoto zooms. I rarely give ultra wide lenses priority over other lenses, but I will happily pack one if weight is not an issue.

The Prime Option

Though much of our discussion so far has focused on zoom lenses, you have an entirely different option available for putting together your lens system: prime lenses. By using a fixed focal length, they can offer vastly superior image quality and much larger apertures than zooms at a fraction of the weight (and often cost). The downside is, obviously, the loss of versatility and the increased need to switch optics.

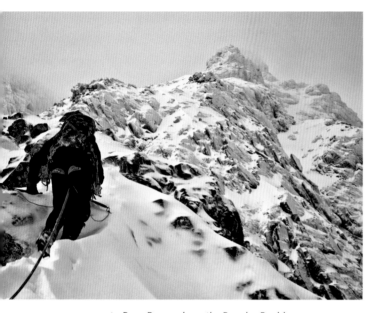
▲ *Dave Brown above the Douglas Boulder on Tower Ridge, Ben Nevis, Scotland. February 2010.*

Using prime lenses should be considered only by experienced photographers who have a good idea of which focal lengths they use most often and will be able to predict with some level of accuracy which lenses they will need on the trip. For instance, a basic system could use a 14 mm f/2.8 for landscapes and extreme perspectives, a 24 mm f/2.8 as a default lens for most environmental shots, and an 85 mm f/1.4 for portraits and the occasional closeup. Obtaining the same speed and high-quality optics from zooms would require thousands of dollars and up to 10 pounds of professional glass!

If you are considering this option, gather some statistics in your photo archives about which focal lengths you use most often—as well as which ones you used to create your best images. You may be surprised to find some numbers appearing much more frequently than others.

Exotics

The final group of lenses is the exotic lenses. Under this category, I would not only put the gigantic telephoto monsters seen in football stadiums, but also all the specialty optics: macro lenses, fisheyes, Lensbabies, perspective correction, etc. If used correctly and not just to create an effect, these lenses can produce striking and original images. However, you are unlikely to use them enough to justify their weight on long trips, and they will probably spend most of the journey at the bottom of your pack—sometimes not even accessible when the perfect opportunity does finally arise.

If you do decide to bring one of these with you, make sure you have a good reason: if your project is to document the flowers of Nepal, you would be justified in packing a macro lens, but if you simply thinking "it could be fun," you would probably end up regretting the decision to pack such a lens.

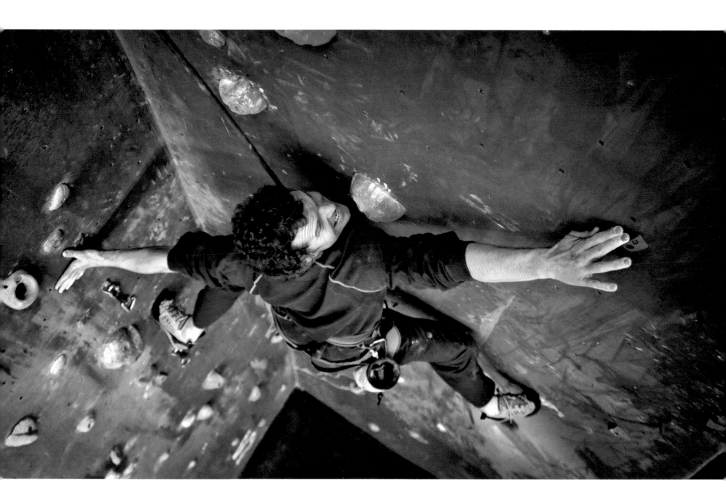

▲ *Amos Richardson on an F7c route in the Reach climbing gym, London. March 2010.*

Carrying Systems

Surprising as it may sound, how you carry your equipment will be far more critical to the number of good images you return with than any other factor. The reason is simple enough: an efficient bag system will allow you to quickly and painlessly access your camera whenever you have a photo opportunity. If every piece of equipment is always easily available, you will be able to shoot in optimal conditions instead of having to make do with a lens because the one you really need is at the bottom of your pack. In short, your choice of camera bag will determine whether you return with photos of only camp and the summit or photos of all the moments that really matter.

Climbing, and to some extent hiking, are activities that require a high level of focus. Once you are in the flow, you will be reluctant to break your concentration and switch to an entirely different activity. Smoothly integrating photography in your day should be one of your main concerns, which will largely rely on reducing disruption to a minimum: opening a pouch on your belt, getting the camera out, and shooting. This process can be done in a few seconds, sometimes without even stopping. On the other hand, if you have to unrope, take your pack off, remove layers of clothing, dig through food, fish for the camera bag, and then fish for another lens, all before you can even put your eye to the viewfinder, you will de facto

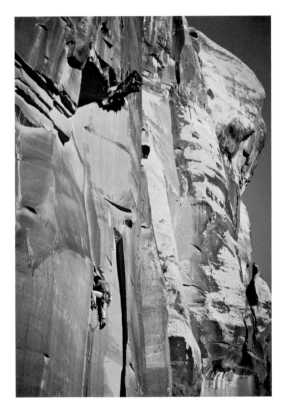

▲ *Certainly not a position where you want to be fiddling with your camera bag. (Andrew Burr photographing Andres Marin on Ruby's Café (5.13a), Indian Creek, Utah. October 2009.)*

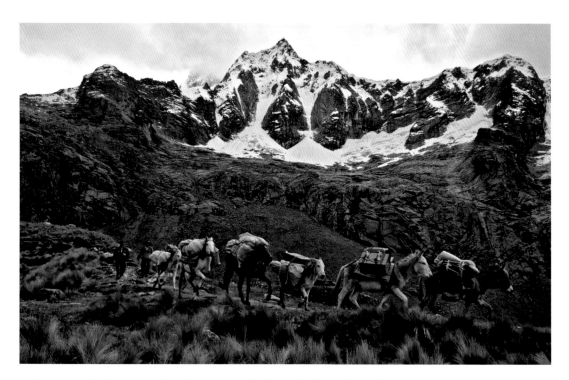

▲ *Caravan on the Punta Union Pass, below Nevado Taulliraju, Cordillera Blanca, Peru. June 2009.*

limit your photography to shooting only when covering easy ground or at other convenient times.

You should spend at least as much time worrying about *how* you are going to carry your equipment as you do about *what* to carry. Of course, the more difficult your itinerary becomes, the more important this issue becomes. The biggest trick of all successful adventure photographers is to have their camera out when it matters most, not just when it's most convenient!

The sad truth about camera bags is that the vast majority of them are inadequate for anything more than short walks in a city, and pretty much awful for long trips outdoors. Most photographers will accumulate bags in their career, trying one model after another on their never-ending quest for the holy grail of carrying systems.

Here are some characteristics of any good bag:

- The most important criterion is that you should have your camera accessible at all times, from the moment you get out of the tent in the morning until you go to sleep at night. If the bag is too uncomfortable, painful, or annoying to carry for long periods of time, you might as well not bring one at all.

- You will almost always be carrying a backpack with survival items (water, food, rain jacket, etc.). Climbers will also wear a harness. You should be able to access all your equipment without having to take anything off.

- A good bag simply stays out of your way and lets you do what you need without fuss—that means when you are not taking pictures, you shouldn't even be aware that you are carrying your equipment.

- The size of the bag should be adapted to the amount of gear you are taking. Even though you may own a dozen lenses, you will probably be hiking with only two or three. A smaller, lightweight bag will allow you to access your equipment more easily and take more photos. Judging what size bag to bring can be difficult when you are using different kits along the way. For example, your bag will suddenly be much too big if you decide to leave the telephoto in camp on summit day.

- All the equipment you might use during the day should be accessible. There's no point in bringing the ultra wide lens if you leave it in the bottom of your backpack because the camera bag is too small.

- Your bag should be reasonably weather resistant. Rain covers are nice when it's pouring, but you probably won't be taking your camera out in that kind of weather anyway. You want a bag that offers enough protection so you do not have to worry about drizzle, fog, or snow.

- Some bags are laden with every imaginable feature, but you probably don't need much more than a couple of internal separators and a small pocket for memory cards and batteries. The simplest designs are usually the most durable and efficient.

- Of course, it should be as lightweight as possible.

Of all the different types of bags on the market, *camera backpacks* are definitely the worst for the outdoors, since you will most likely have another pack on already, even on short easy hikes. Unless you are a world-class alpine climber, hiking without basic survival equipment is simply irresponsible (see chapter 6 on safety).

A *chest bag* offers good access to your equipment and, if you can connect it to the backpack through its straps, it transfers the camera weight onto your hips. However, the deal breaker is that they tend to hide your feet from view—unacceptable and dangerous on all but the nicest of paths.

A *shoulder bag* can work well, but it can also swing annoyingly with each step and balance the pack weight asymmetrically, which can cause pain in your back and shoulders over long periods of time. They are not recommended for technical climbing.

Finally, a *belt system* is, in my opinion, the best solution. It simply consists of a padded belt and a few detachable pouches, and it fills all the climber's needs: It distributes weight over the hips. It can be worn below a pack and above a climbing harness. It does not get in the way—even on technical climbs. And finally, most belt systems are modular, so you can adjust the size of your carrying system, reduce wasted space, and keep weight to a minimum.

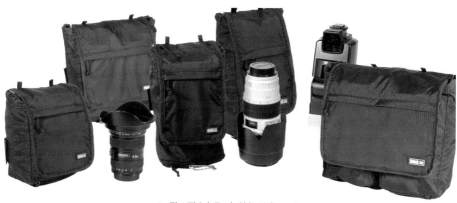

▲ *The Think Tank Skin Belt system.*

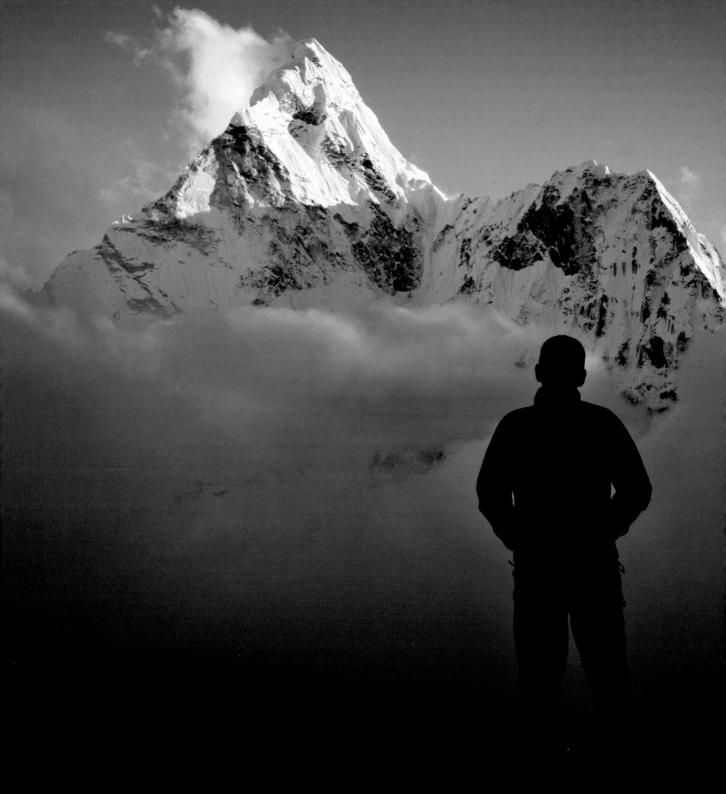

Battery and Memory Strategies

On any trip, you will need to manage two important resources: power for the camera and memory cards (or film rolls). This task is obviously of utmost importance, as running out of either resource would mean no photography at all. Your goal should be to obtain not only continuous availability of both resources, but also the *perception* of continuous availability, for if you fear you will run out of memory or battery life, you will be pushed to shoot less. When it comes to selecting batteries and memory cards, weight and cost factors are of less importance than for other equipment. You should always feel secure that you will be able to shoot at any given moment. In other words, I would be happy to leave a lens that was too heavy for a trek, or take a cheaper DSLR body that still gave me adequate image quality, but I could never justify bringing too few batteries to save weight or money!

It really pays off to give this issue a lot of thought well before leaving and to have a clear strategy. One useful approach is reviewing statistics from your previous trips: rather than relying on the manufacturer's optimistic figures, find out from your own experience how many images you can realistically shoot on

◀ Norrie Rodgers admiring Ama Dablam at sunset, Khumbu, Nepal. October 2010.

a battery charge, as well as how many images you shoot on an average day in the mountains and how much disk space you need to store your daily images.

Finally, even if your strategies are detailed and thought-out, you should still keep an eye on your actual battery and memory usage. Photographers have often been known to miscalculate their needs. Carefully monitor your camera at all stages of the trip, so you can foresee and avoid any future mishaps, such as a sudden lack of memory space several days away from the closest electronics store.

Managing Memory

Having a large amount of available memory is doubly important: not only do you not want to run out and become unable to photograph at all, but you also don't want to think that you *may* run out at some point, and have to ration your photos accordingly.

There are two strategies to memory management. The first is to consider memory cards as film rolls: pack as many as you think you need, and once full, store them securely until you get back home. While this strategy has the advantage of simplicity, it has many downsides. For one thing, any mistake in your initial estimate could be catastrophic. Most likely, you will grossly overestimate your needs and bring far more memory than you will ever use. Even with

costs decreasing, buying that many memory cards is a significant investment. Because camera resolution gets continually higher, you actually use more gigabyte space than before, which offsets the decrease in price. Furthermore, unless your budget is unlimited, you probably won't buy the fastest and most reliable cards, which is a gamble. Finally, the biggest problem is the inability to backup your images before you access a computer, leaving you entirely at the mercy of a card loss, an accidental overwrite, or a simple memory corruption, all of which are known to happen frequently.

The alternative strategy is to bring portable hard drives, self-powered and with the capability of directly downloading the content of a memory card. This strategy permits you to carry just enough memory for a day of shooting, transfer the photos to the device every night, and then reformat the cards. Better yet, if you carry *two* hard drives, you introduce a measure of security, as storing your images in two different locations will dramatically decrease the chances of losing any data. The major downsides of this solution are it adds additional weight to your pack and you have to monitor the battery level of yet another electronic gadget.

Whatever solution you end up choosing, you will at least need enough cards to get you through one

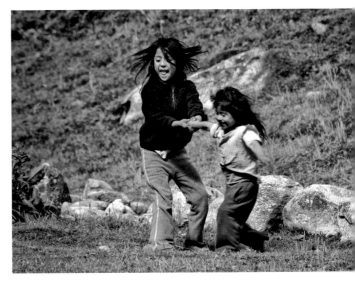

▲ *Peruvian kids playing in the Santa Cruz valley, Cordillera Blanca, Peru. June 2009.*

day of shooting. Concretely, take the highest number of photos you will realistically shoot in one day, and add 50% to that figure. For instance, with my 12 megapixels camera, and unless I am shooting action, I feel safe with a total of 10 to 12 gigabytes in memory cards—about 1000 pictures.

Staying Powered On

Much more problematic than memory, however, is battery management. The price to pay for all the new shiny features on your fancy digital camera is that, without an adequate power source, it becomes an expensive paperweight. To make things worse, cold is the deadliest threat to batteries, making them drop

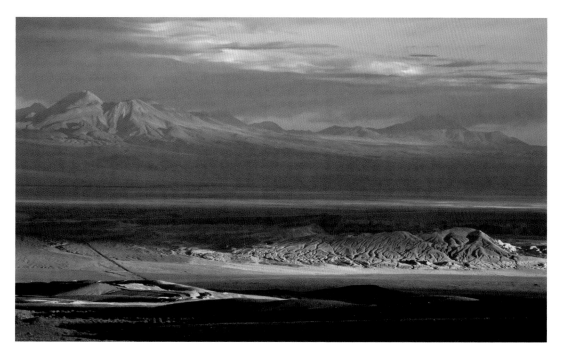

▲ *Sunset over the Atacama Desert, Chile. September 2007.*

to a fraction of their normal capacity as soon as temperatures get below a certain threshold. However, as soon as they are re-warmed, the batteries should return to their full capacity. Unless you are on a daytrip and confident that you will shoot no more than a few hundred frames, carrying extra batteries is crucial. The number necessary will depend on many factors: how long your camera usually lasts; how much you use power-hungry features such as long exposures, LCD preview, movies, or autofocus tracking; how long you will be without access to a power plug; and how low you expect temperatures to get. Peace of mind alone often offsets the extra weight and expense of bringing one battery too many.

Solar powered chargers are available, but except on very long expeditions or very static trips, they will rarely be worth their weight, as you need a rest day with good weather to charge a single battery. Even if you do carry one in the wild, make sure you do not overly rely on it, and bring enough batteries to get through your trip.

Careful and constant monitoring of your power sources is extremely important. I tend to be very conservative at the beginning of a trip and re-evaluate on the way. If I realize that I have more power than planned, I will allow myself some luxuries, such as reviewing daily photos in the evenings and checking sharpness at 100%. Conversely, if I expect power to be an issue, I will disable the screen entirely and cut down on long exposures. Flexibility is key.

When planning your trip, spend some time trying to guess where and when the best photo opportunities are most likely to appear. They could appear during a summit push, in a pass overlooking some famous mountain, at a local village, etc. This type of planning will help ensure you have enough power when those moments arise. You may even wish to reserve an untouched battery for those special occasions (a common practice for summit days on climbing expeditions). Also take into account that you will tend to take better photos toward the end of a trip,

simply because you will have more experience and will know what works and what doesn't, but that it is also when your power is most likely to run out.

It is natural to shoot a lot while in camp because you can fully focus on photography and light is likely to be better in the mornings and evenings than at the height of the day, but you should be careful not to eat too much power, especially if you shoot long exposures. Using a dedicated battery for camp shots can be a good solution to keep things in check.

Finally, if you think cold might be enough of an issue to hinder your shooting, there is a simple solution: keep a full battery in a chest pocket, as close to your body as possible, and switch out the active one whenever it gets too cold. Except in really brutal conditions, the extra battery will warm up faster than the other one loses capacity. If you want to be able to shoot as soon as you wake up, you may wish to spend the night with the batteries inside your sleeping bag.

▶ *Trekkers below the north face of Ama Dablam, Khumbu, Nepal. October 2010.*

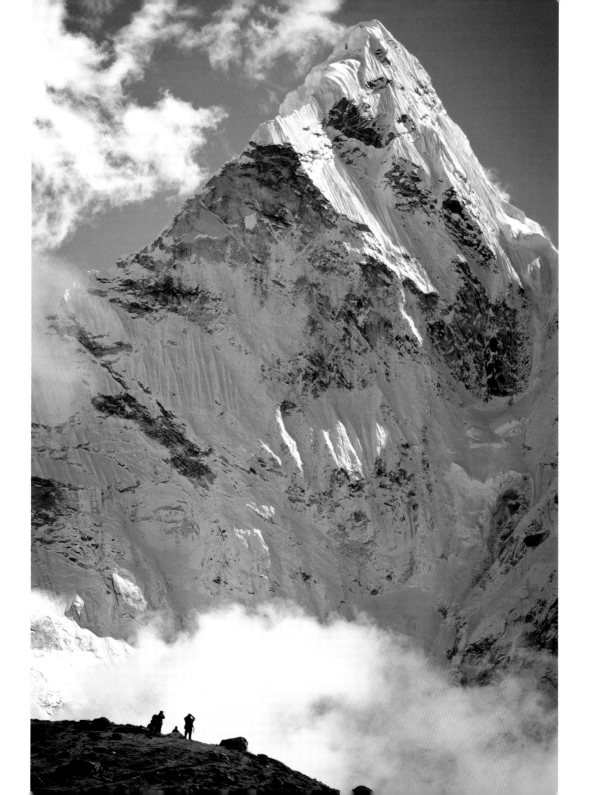

Odds and Ends

A little web browsing can be disastrous to photographers! The web has hundreds of photo accessories marketed as absolutely essential, and once you start buying some, you will find your bag filled with junk you rarely ever use before you know it.

As with any other piece of equipment, you should be careful to only choose accessories that are strictly necessary and will make a real difference in your photography—either in the final image quality or in making your life easier while you are shooting. And very few do. Here are some of the true essentials:

- Mountain environments can be pretty harsh on your lenses, especially if you follow my advice and leave lens caps off during the day. (See chapter 2 under "How Not to Drop Stuff".) *UV filters* help protect the front element and can offer you some peace of mind. They can also help reduce condensation—a photographer's trick (discussed in chapter 2 under "Weather Protection"). Be sure to choose a multicoated filter of good quality, so as not to impact the optical quality of the lens. High quality *clear filters* will also protect your lenses well.
- *Lens hoods* are crucial, both for physical protection and for getting the best image quality from your lens. When scattered light hits the front element at an angle, even when it doesn't produce lens flare, it will reduce contrast and sharpness of the resulting image.
- You should always carry a *microfiber cloth* to wipe off dust, mud, rain, or snow from the lens. A simple tissue will do in a pinch, especially if you have a UV filter on, but microfiber reduces the risk of scratching.
- I would also suggest bringing a *pen* and something to write on (I carry a small notebook) to note addresses of people you meet, mountain names, technical details, etc. Also, use it to give your contact information to your fellow hikers.
- Finally, you might want to consider printing a few *release forms* and stuffing them in a pocket of your bag. If you ever want to use your photos commercially, you will need permission from every recognizable person in the image, which might not be so easy to do once you are back home with no idea how to get in touch with them.

▶ *Rune Bennike on Great North Road (HVS 5a), Millstone, England. June 2010.*

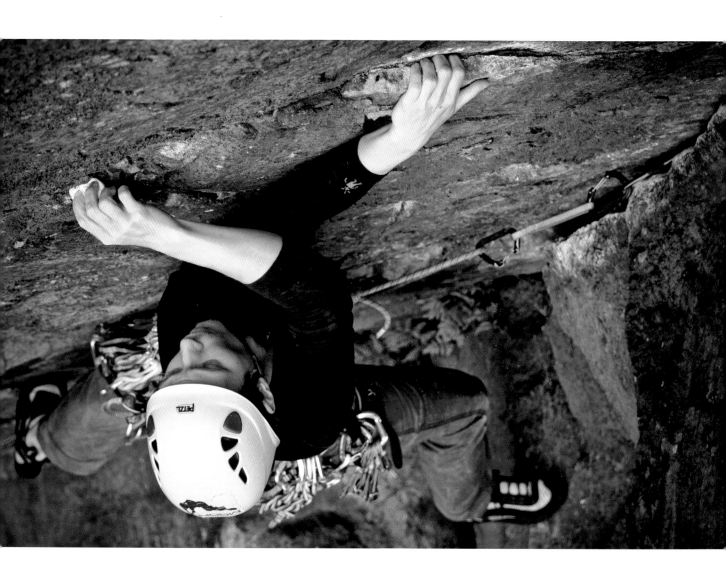

Dead Weight

Some common pieces of photo equipment haven't been mentioned yet. The reason for this omission is that they all share an important characteristic: except in rare cases, I don't find them useful enough to justify their weight; therefore they should stay at home — or at least in the car. These pieces include the following: tripods, artificial lighting, some screw-on filters, and laptops.

The Tripod Issue

To many photographers this next statement will be sacrilegious: a tripod simply isn't a very useful tool in the mountains. One of the reasons its use is commonly recommended is that a tripod forces you to slow down, take your time, and really think about composition and what you are trying to say with each image. While this technique is very laudable, it's also the opposite of the kind of workflow you should be engaging in while hiking or climbing: fast, practical, and fuss-free. The time and effort it will take to set up the tripod will make the act of photographing such a hassle that you will be less likely to stop, and ultimately, you will return with fewer images.

Since you will, by definition, be outdoors, you will be able to comfortably shoot handheld most of the time, even with rather slow lenses, especially since modern DSLRs have remarkably low noise at moder-ately high ISOs. Low light is only an issue before sunrise or after sunset, and it's only during these times that long exposures make a tripod truly useful. However, a little creativity is often all you need to find a platform stable enough to get the shot. (See chapter 5 on "Low Light and Night Photography".)

Artificial Lighting

If you have lots of time and easy access to the shoot location (which usually means cragging, indoor climbing, or bouldering), using studio lighting techniques and several remote flashes can help create a unique look for your rock climbing photography — but as always, use lighting as a tool and not for its own sake.

For any other shot, flash is more trouble than help, and it's rarely worth packing one. Not only will you need (many) additional sets of batteries, but you will also need to invest time and effort into setting up a stand, some light modifiers, a radio master, etc. Using a small unit for on-camera frontal fill might be useful for balancing portraits with outdoor backgrounds, but you must take great care if you want to avoid the "party picture" look that hard frontal flash generates by default.

▶ *Descending Nevado Chopicalqui in bad weather, Cordillera Blanca, Peru. June 2009.*

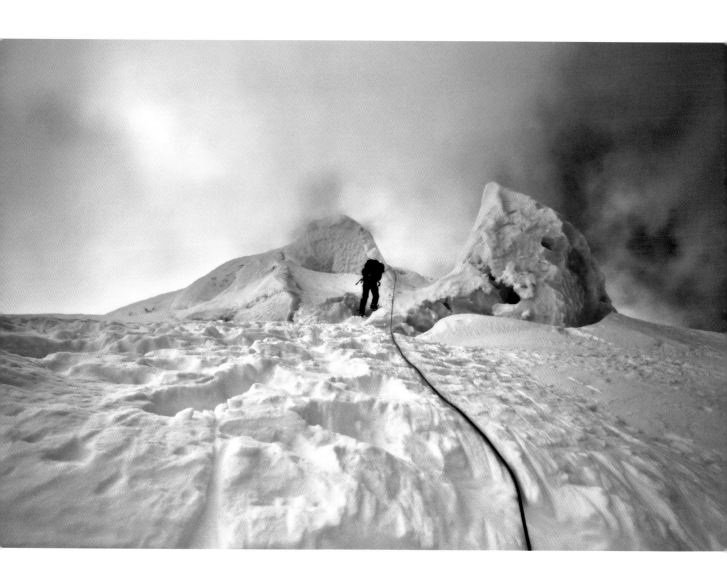

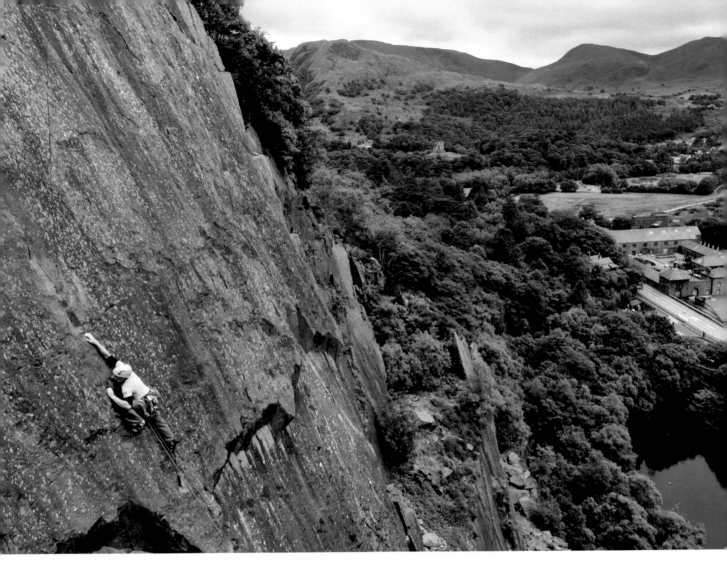

▲ *Gareth Leah on Comes the Dervish (E3 5c), Llanberis, Wales. July 2010.*

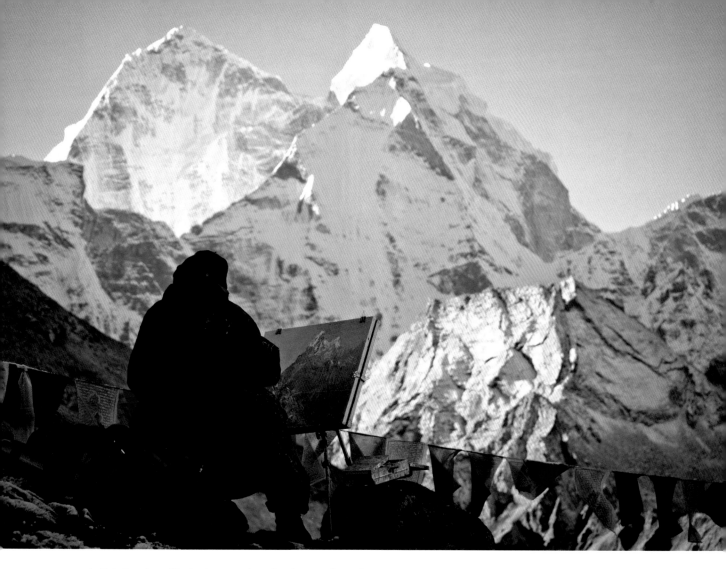

▲ *Painting above Dingboche at sunrise. Khumbu, Nepal. October 2010.*

Filters

The need for screw-on filters has been greatly reduced by digital workflows and careful post-processing, thus reducing the need to mess with one more accessory in the field. Here are the main types you can find:

- **Colored filters** – These types of filters have almost totally disappeared since RAW files allow a global modification of white balance in post-processing.
- **Neutral density filters** – These limit the amount of light going through the lens and are mostly used for effects, such as giving running water a dreamy look. Their main drawback is that they will almost always require the use of a tripod. Most likely, you would want to use them only in camp anyway. Instead, you can wait for sunset and low light so you have the desired shutter speed without needing the filter.
- **Graduated neutral density filters** – These filters can be very powerful for shooting in high-contrast situations (typically a bright sky with a dark foreground), but they only work if the separation between dark and bright is completely straight — and flat horizons are not very common in the mountains. They also need to be mounted with

▲ *Jon Fullwood and Simon Wilson bouldering in Curbar, England. March 2010.*

a special holder, which, quite frankly, is a pain to use. Save yourself the headache and bracket for HDR instead. (See chapter 5 for more on HDR imaging.)
- **Circular polarizers** – Circular polarizers can occasionally be useful, especially when water or heavy vegetation is involved in the image, but their main effects (darkening and saturating the sky) can easily be reproduced in post-processing.
- **UV or clear filters** – As discussed above, UV or clear filters can add a welcome extra layer between your expensive lens and a hostile environment.

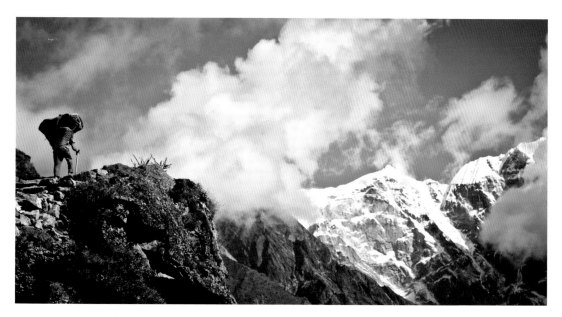

▲ *A Nepali porter on the trail to Dingboche, Khumbu, Nepal. October 2010.*

Laptop

Laptop computers have arguably become one more photography accessory, and some advocate packing a lightweight model on long trips for the immediate review and backup of your images. While having a laptop around may occasionally be convenient, it will also add a lot of worry: it will require being close to a power outlet most of the time; it will attract attention from potential thieves; and it will add a lot of weight to your pack, as even ultra-mobile netbooks weigh a hefty 3.5 to 6 pounds. You can just as efficiently back up images with a portable hard drive, and the low-resolution, low-quality laptop screen will not allow you to do anything more than casual reviewing anyway. Finally, you probably decided to go play in the wild to escape technology for a while, so it would be a shame to spend your time looking at a screen when the real deal is just outside your tent!

So, What *Do* I Bring?

Having discussed all the options, I'll share with you what I actually take on my trips. This list changes as new equipment appears and as my own photography evolves, but here is a snapshot of the gadgets inside my bags in the winter of 2010.

For Hiking and Less Demanding Climbs

Unless I have a particular reason to go extremely light, my kit consists of the following:

- The **Nikon D90**, a middle-of-the-line DX DSLR, which is a good compromise between weight and features.
- My workhorse lens is the Nikkor 16-35mm f/4 VR. It has a somewhat limited focal range but is optically excellent, and the optical stabilization allows me to shoot in very low light.
- I use the **Nikkor 70-300mm** f/4.5-5.6 VR lens for the extra reach, and it has brilliant optics in a rather small body. If I expect a hard day, I won't hesitate to leave it in camp.
- All my equipment is carried in the **Think Tank Skin** belt system, which is by far the best I have ever used. The main difference between this belt and other belts is that it has no padding in any of the pouches and is very low weight. These bags also have their own rain covers, which keeps my equipment dry in bad weather.

- Depending on the length of the trip, I will carry two or three batteries for the D90.
- I have two **Colorspace UDMA** portable hard drives for multiple backups.
- I carry 10 to 12 GB worth of SD cards, the main one being a 4 GB high-performance Lexar 133x. On a 12 MP camera such as the D90, I know this amount of memory is more than enough for a busy day of shooting.
- Both lenses are equipped with a **Hoya HMC UV filter**, which is permanently left screwed on.
- Finally, I carry a microfiber cloth, a small notebook, and a pencil in a pocket of my bag.

For Difficult Climbs

If I need to shed weight and focus on the climbing itself, I have to make compromises:

- Instead of a heavy DSLR, I bring the **Olympus EP-1 Pen Micro Four Thirds** camera.
- For versatility, I bring only one zoom lens: the **Zuiko 14-42mm f/3.5-5.6**.
- I still use the **Think Tank Skin** and simply strip it down to the belt and one small pouch.
- I use the exact same SD cards as with the D90.
- Though it is significantly riskier, on short trips I only bring a single **Colorspace** portable hard drive.

▲ *Sunrise from the summit of Nevado Yanapaccha, Cordillera Blanca, Peru. June 2009.*

Shooting

Chapter 2

So far, our discussion has centered on the decisions you need to make months in advance of your actual trip. But once you have bought and packed your gear, you will have to live with your equipment selections and make the best of what you have at your disposal.

Once the expedition is under way, there are many considerations to keep in mind, which will be the subject of this chapter, but before we go any further, you need to understand one thing: If you are reading this book in preparation for an expedition to some remote corner of the world, or just for a big trip, do *not* expect to learn how to use your new gear or experiment with new techniques when you are out in the field. Make sure to always test and refine any new ideas on small trips, close to home, where missed shots aren't too catastrophic. The experience you will gain through this process of trial and error will be invaluable; when you're comfortable with your equipment, you will be able to start shooting right away, when it really matters.

▶ *Hermann on an exposed traverse, Nevado Chopicalqui, Cordillera Blanca, Peru. June 2009.*

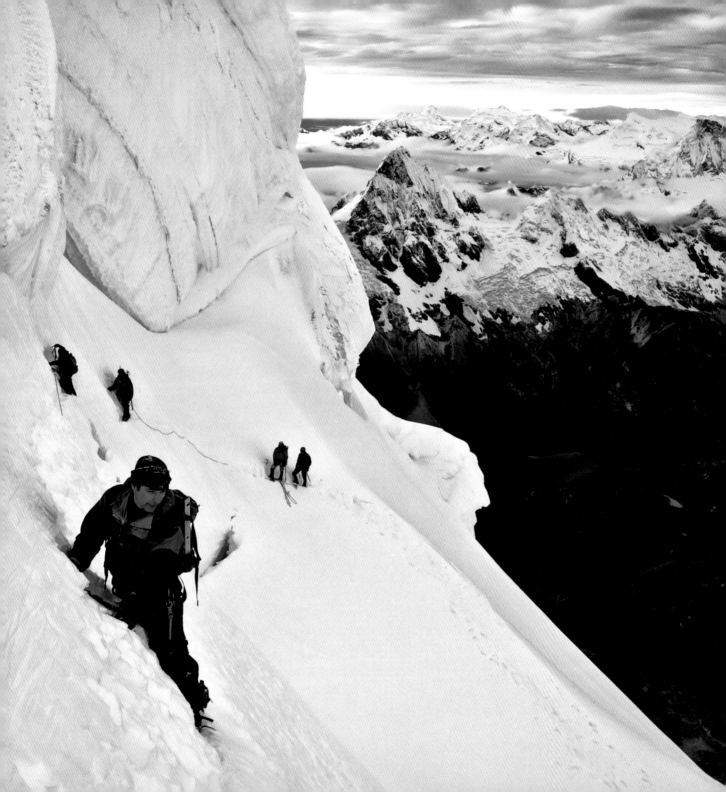

When to Shoot

The most important message of this book is this: no matter what terrain you are on, you should *always* have your camera available, so you can be ready to shoot in an instant. An efficient bag system will help you achieve this goal (see chapter 1), but you also need the right mindset: If you get used to the idea of being able to take pictures in all kinds of conditions, you will discover an immense wealth of photo opportunities.

The best and most striking images often arise when you least want to shoot, as this is when the action and emotion of the climb is at its peak. Be psychologically prepared to stop in very inconvenient places. The key is to integrate photography in the rest of your mountain activity by making each snapshot a short and simple action. Even on difficult climbs, I often stop briefly when I see a good image opportunity, get the camera out, frame, shoot, and store it back in no more than 10 seconds. No fuss.

There are a number of considerations to examine before deciding to stop for a picture. You can use the following as a mental checklist to go through every time you see a potential photo:

- How safe is it to stop now? Are you or your partners in a precarious position? Can you use both hands freely without risk of falling? Is there any risk of an avalanche or rock fall? If you are belaying someone, are you using an auto-locking device, which can check a fall while you are busy photographing?

- How are your partners going to react? If you are roped together, they will have to stop as well. Will they be comfortable? If you are not roped together, are you going to fall behind, and will you be able to catch up later on? Are you already running late, threatened by nightfall or snowmelt?

- How long is the photo opportunity likely to last? If the composition relies on the exact position of a particular cloud around a peak on a windy day, you need to act very fast. If on the other hand, you think the scene won't change too quickly, it may be worthwhile to wait for a safer time to take a break.

- How good is the image going to be? There is no need to stop a whole party if you only want to get the fifteenth variant of the same image. Conversely, a great scene can warrant stopping everyone dead in his or her tracks.

It is crucial to discuss your goals with your partners before the actual trip. Make sure they all know that photography is important to you and that you may need to frequently stop in places that are not the most convenient. Listen to their objections and consider sacrificing some photo opportunities in the interest of preserving your relationship with your teammates. Respect flows both ways!

When in doubt, and if it's safe to stop, just shoot. You will be able to delete poor images later, but you will not be able to come back to a missed photo opportunity. (If you are concerned about shooting too much, see chapter 3 under "Quantity vs. Quality".)

Finally, take advantage of every planned break in your hike or climb. These breaks provide you with fewer external distractions and allow you to really focus on creating the best possible images. Only relax and rest when you are convinced there are no more good images to be found!

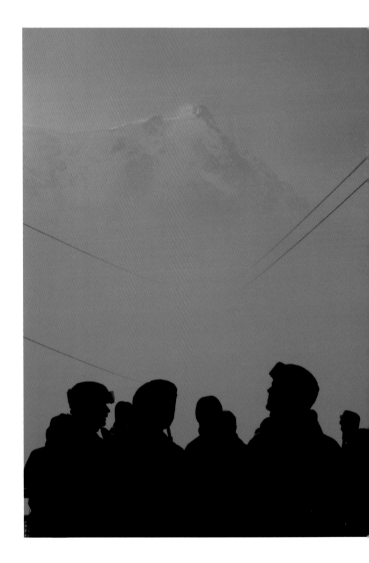

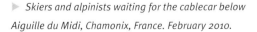 *Skiers and alpinists waiting for the cablecar below Aiguille du Midi, Chamonix, France. February 2010.*

Caring for Your Gear

Weather Protection

Mountains can be some of the most hostile environments on the planet, and even in good weather, the natural conditions will be very different from those of a mild urban setting. Every outdoor photographer should be prepared to fight cold, heat, humidity, sand, rain, snow, and dust.

Some cameras and lenses, mostly on the high end of DSLR line-ups, are advertised as being weather sealed. Generally speaking, more expensive equipment will be better built and able to survive worse weather, but with reasonable care and preparation, it is possible to use even flimsy plastic bodies in truly horrible conditions.

Cold

Cold weather will make your own body cease to function properly long before your camera. Even at night, hikers rarely encounter temperatures low enough for electronics to malfunction, and if climbers do, they then have much more pressing things to worry about, like keeping their fingers and toes, for instance. As a rule of thumb, temperatures above -5°F (-20°C) should not have any other impact than making LCD screens a bit sluggish.

Cold has two important effects, however. As was already discussed in chapter 1 in the section "Battery and Memory Strategies", battery life will be drastically reduced as temperatures drop—though it should come back to normal after reheating. Carrying a second battery in an inner pocket is a cheap and easy way to work around this problem. The other main consequence is that you will be forced to wear gloves or even mittens, which makes buttons and dials much more difficult to operate, increases clumsiness, and heightens the chances of dropping your equipment. It is very important, however, to always use your camera with adequate gloves. Frostbite can happen in a matter of seconds, often without the victim realizing it, and far too many mountaineers have already traded their fingertips in exchange for a few photos.

Water

Precipitation, in all its forms (rain, snow, fog, hail) is the nightmare of every outdoor photographer, and you should spend considerable effort protecting your equipment from water, but you should also understand how much damage each form of precipitation is likely to cause. That way, you will only put your equipment away when it is truly in harm's way.

▶ *Bush plane over the Ramparts, Alaska Range.*
August 2008.

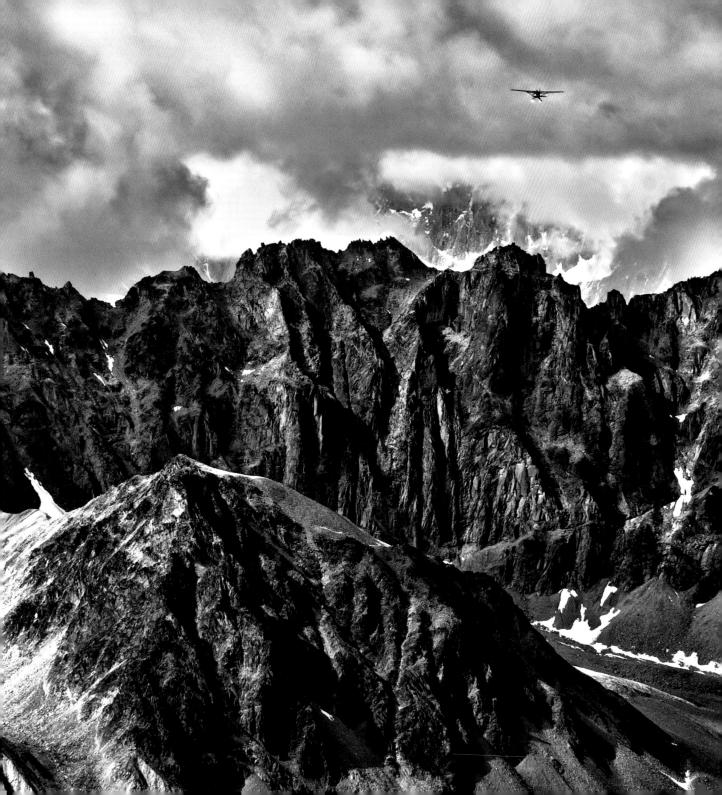

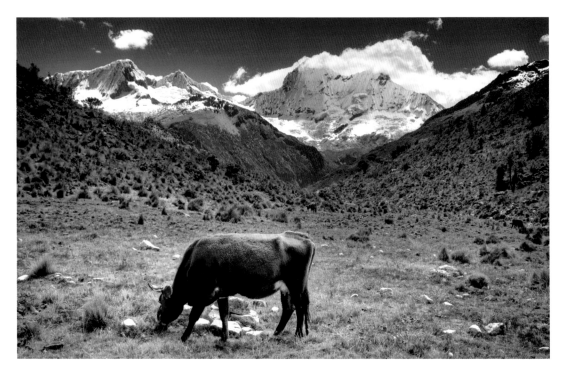

▲ *Pastural basecamp for Nevado Chopicalqui, Cordillera Blanca, Peru. June 2009.*

For instance, all but the most poorly built cameras will be just fine in fog, a light drizzle, or dry snowfall. Hail, on the other hand, can cause physical damage to the gear—as well as to the photographer!

High levels of humidity or proximity to seawater are causes of concern in the long term because cor-rosion and fungus can eat through metal and plastic with surprising speed. If you plan to spend a signifi-cant amount of time in very wet areas (e.g., the sea-side, the rainforest, or Scotland), pay a premium for weather resistant gear; it will be money well spent. Stashing small packs of silicate gels in your camera

bags is also a good idea, and you should use every opportunity to let your gear dry completely.

The biggest threat of all, however, is rain. Unfortunately, the only sure way to know just how much rain your camera can take is to leave it unprotected until it fails—not exactly the most practical advice! Common sense applies: In a downpour, put all your equipment away in waterproof bags, even a garbage bag will suffice. If rain is lighter, you may take a few shots, but try not to leave your gear exposed for too long. Also, be wary of raindrops on your lens, which can result in locally blurred images, and are sometimes hard to detect when shooting. When shooting in or just after the rain, always check the front element, and give it a quick wipe when needed.

If you are planning to travel in a very rainy region for extended periods of time, you might think about investigating protection systems (glorified plastic bags with a hole for your lens) that allow you to keep shooting in adverse conditions. But you should also take into consideration that rain will mean low visibility, diffused light, and a wet photographer—and none of these circumstances are conducive to creating good images.

▶ *Katsutaka "Jumbo" Yokoyama belaying in Indian Creek, Utah. October 2009.*

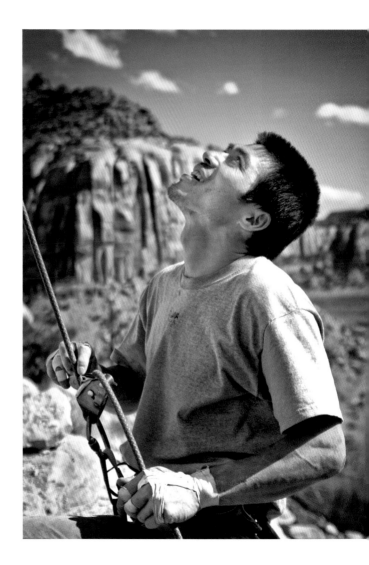

Condensation

Combining the previous two problems, condensation is what happens when your environment suddenly heats up, with ambient humidity turning into liquid water on the still cold surfaces of your camera and lens. This usually happens when you enter a warm hut or shelter. Metal and glass, which conduct heat more easily, will be more susceptible than the plastic surfaces of most cameras. Once the body of the camera is warmed to the ambient temperature, which usually takes a few minutes, the condensation will disappear. A cheap and easy way to avoid condensation entirely is to put all your equipment in a sealed plastic bag before entering the hut: this will allow the camera to warm up to room temperature in a moisture-free environment.

Condensation is a problem for two reasons. First, if you return outside before the warming process is complete, any water layers on your camera can freeze. Should this happen, the safer solution is to warm the icy surface and wipe it clean as soon as possible. Be sure to use a dry cloth to do the wiping; even a glove will moisten the lens enough for it to form a layer of ice again. Second, condensation can cause water to slowly infiltrate inside your gear and start corroding the electronics, ultimately leading to complete equipment failure a few days or months later. Again,

cheap cameras will be much more vulnerable than better-sealed bodies, but a cautious attitude is the best guarantee.

If you ever find yourself in the unfortunate position of having a great photo opportunity but a fogged up lens, simply unscrew the UV filter, shoot before condensation has time to form, and put the filter back on, dealing with condensation later. You just need to be careful not to trap any excessive moisture between the front element of the lens and the filter.

Dust

Digital cameras introduced a new issue for photographers: Since the photosensitive surfaces do not change between shots, any trace of dust on the area will appear as a defect on every single image. It is generally straightforward to fix dust spots in post-processing, as long as they do not appear on a crucial element of the composition, but since this process is difficult to automate, it can be very time consuming.

The good news, however, is that most recent cameras possess some anti-dust system, generally with a small motor that shakes the sensor at a high frequency every time the camera is turned on or off. Those systems tend to work very well, though proper sensor cleaning will still be necessary to get rid of the biggest, stickiest impurities.

To reduce this problem, be extra careful when changing lenses. Shelter your camera from the wind by turning your back to it. Try to minimize the amount of time your body is without a lens, and turn the camera off before proceeding, since static electricity on the sensor will attract dirt particles.

After more than a decade of snowboarding, I decided to go back to skiing last season so I could access the backcountry more easily. This choice meant a lot of, shall we say, unplanned horizontal stops, especially in piles of powder. On a recent Vallée Blanche descent, in Chamonix, I probably fell a dozen times in thigh-deep powder, with the Olympus Pen in a non-waterproof belt pouch. The camera (as well as myself) was encrusted in snow for the best part of the four-hour-long descent; temperatures were below −5˚F (−20˚C); and yet the camera functioned flawlessly. I wish I could say the same of the skier!

How *Not* to Drop Stuff

Many climbers, as well as some hikers, unfortunately decide not to bring their nice cameras on expeditions for a single reason: They are afraid of accidentally dropping their expensive gear down a cliff. Though it definitely is a risk, and has been known to happen on more than one occasion, it is also largely preventable.

With unruly mittens, cold fingers, high altitudes, and awkward stances, everyone can find it easy to be clumsy. A basic rule is to assume that you *will* drop equipment and to devise some safety system to ensure that falls are not long enough to cause real damage. Concretely, this means securing your equipment to yourself.

The easiest way to do that is to connect the camera strap to either your harness or your bag—a simple carabiner will do the trick. You can either reconnect the carabiner every time you take the camera out, or if you want to be extra cautious, you can use a small climbing sling, which is girth hitched to the camera strap, fed through an opening in your bag, and is connected to your harness at all times.

If you are not wearing a climbing harness but still want the extra security, a simple chest harness can be fashioned with a double-length (120 cm) sewn sling and a carabiner: Form a figure 8 shape with

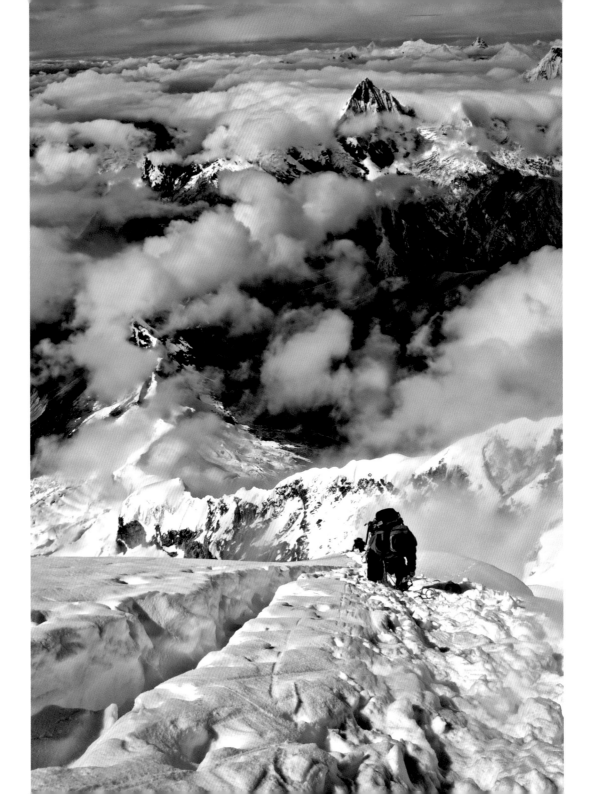

the sling, put an arm in each loop so the strands are crossing in the middle of your back, and then connect the loops with a carabiner on your chest. This harness is also useful if your camera strap is so short that connecting it to a regular seat harness reduces your range of motion.

With your camera now safe, the most dangerous operation becomes changing lenses. Unfortunately, you cannot attach a safety leash to most lenses, so it will be entirely up to you to not drop them. The most important thing is to never manipulate more than one item at a time: First take the old lens out, stow it away, and then grab the new lens. The camera strap should be around your neck during the whole operation, so that both hands are free. Finally, try to work above an open bag, as this will give you one last chance to catch any falling objects.

I have never dropped a lens, and only very rarely my camera, but gravity seems to apply more forcefully to lens caps and other small objects. Some advise drilling small holes in them, connecting them to the filter thread of the lens, but I find that a much more efficient system is to not use them at all. UV filters and hoods are protection enough, and there shouldn't

◄ *Hermann descending the summit mushroom of Nevado Chopicalqui, Cordillera Blanca, Peru. June 2009.*

be anything susceptible to scratching glass in your bag anyway. Simply remember to pop them back on when you are storing the camera away for a long time. As for switching out batteries, memory cards, the occasional filter, and similar small objects, the easiest solution is to do all the manipulations *inside* the bag—awkward, certainly, but also a lot safer.

Finally, be prepared for contingencies. Before departing, take a moment to think about what you will do if you lose an important piece of equipment. If it means no more pictures at all, it may be worth bringing a light-weight backup camera.

Safety

Big cameras and nice lenses aren't very discrete items to carry around, and they tend to scream, "Steal me!" to everyone around, especially in underdeveloped countries where many of the great treks and climbs are located. Expensive-looking electronic equipment tends to disappear from checked-in luggage, and in foreign cities, a moment of distraction is often long enough for a camera bag to walk away. There are a few rules to be observed: On airplanes, always pack anything fragile or expensive (as well as your film rolls, if you still use film) as carry-on luggage. Never leave bags out of your sight, and if on the ground, always keep them attached to yourself; for instance,

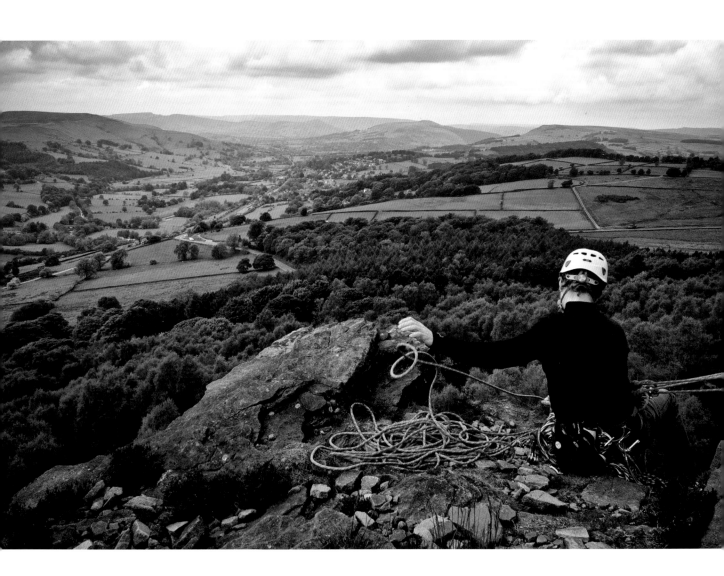

secure your camera bag with a strap tied around your foot. You should be especially careful in cafes, when loading and unloading a vehicle, or in any situation where your attention is focused on an external task.

In third-world countries, public transportation is particularly dangerous, and you should never put anything in the overhead compartments nor, in the case of overnight trips, at your feet. A camera bag on your lap is the only option that will give you a standing chance at keeping your gear. In big cities or sketchy neighborhoods, try to be as discrete as possible, and use caution generously. No photo is worth the risk of getting attacked.

◀ *Rune Bennike belaying above Millstone, England. June 2010.*

▶▶ *Next page, left side: Skydiver in front of Kongde, Khumbu, Nepal. October 2010.*

▶▶ *Next page, right side: Trekker in front of the majestic Ama Dablam, Khumbu, Nepal. November 2010.*

To date, I have spent two months in South America over several trips, and I have been assaulted twice— on the same day! On the first occasion, in the old town of Quito, Ecuador, I was carrying an obvious shoulder camera bag and was "accidentally" sprayed with mayonnaise by someone. A "passerby" saw the incident offered to help me clean up a nearby restaurant. Thankfully, I knew his idea of "help" meant that he would grab my bag and sprint away with it as soon as I took it off—sadly, this is a very common scheme. Later that same evening, just a block from my hotel, I was physically assaulted by three men who started choking me. Luckily, they were only after cash, and since I was just out for some food, I had no valuables and only ended up with a good scare.

Finally, a friend of my sister's had the unfortunate experience of having his shiny new Nikon D80 stolen from its camera bag on a Peruvian overnight bus. He had the camera bag at his feet with the strap tied to his leg, but during the night, someone crawled under the seats, opened the bag, and neatly removed the camera. The unfortunate photographer only realized what had happened hours later, and the thief was long gone.

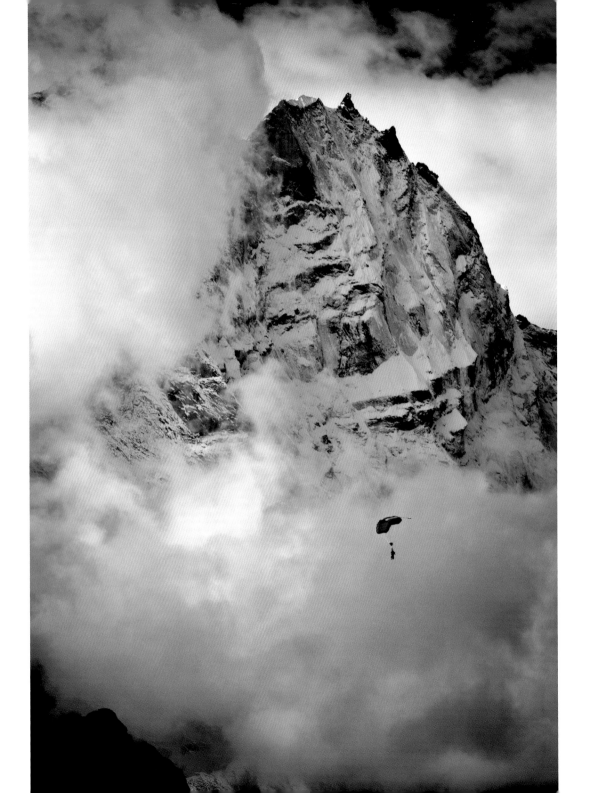

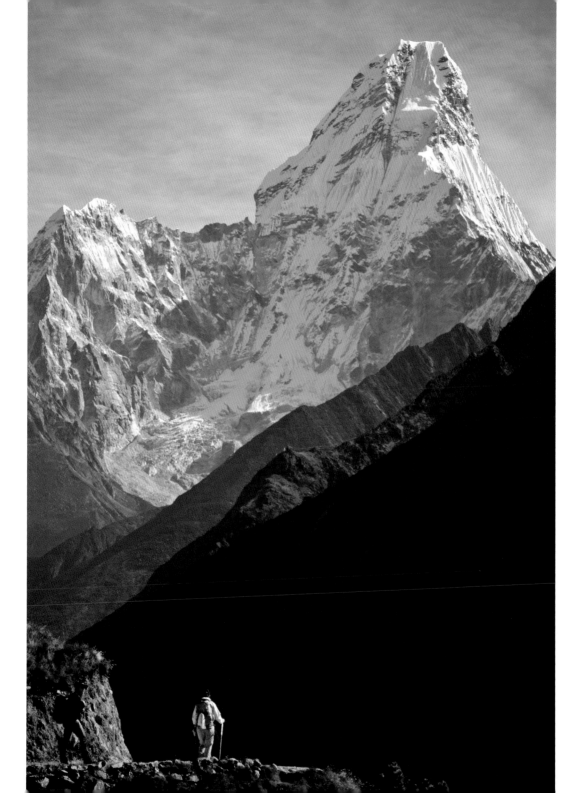

A Complete Workflow

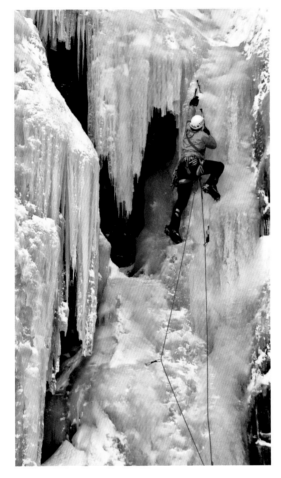

▲ *Climber on a WI4 waterfall, Rjukan, Norway.*
December 2009.

Here is the complete sequence of steps I typically go through when taking a picture on an expedition. Despite the large number of items on this list, the process actually goes very quickly. The goal is to try and automate all of these tasks so that they become second nature. Overlooking any of them can, and in time, will, make you miss photo opportunities.

- Keep an eye out and an open mind for any potential photo.
- When you see a good photo opportunity, assess how safe and convenient it is to stop (see chapter 5 under "Safety and the Environment").
- If you are not alone, let your partners know that you want to stop to take a picture. Always try to give them a time estimate (ideally, no longer than a minute or two). You can either ask them to wait for you or tell them you'll catch up as soon as you are done.
- If the terrain is too uneven, anchor yourself somewhere so that you can focus on photography and not on keeping your balance at all costs. If you are in the middle of a hard climb, you may have to climb a bit further to be able to place rock or ice protection for your personal safety.

- Get into a comfortable position, one in which you are free to use both hands (e.g., stand in a solid stance, brace yourself against a rock, or even sit or lie down).
- Open the camera bag.
- If there is any chance you might drop something, clip the safety leash of the camera to your harness (see chapter 2 under "How Not to Drop Stuff").
- Put the strap around your neck, and then pull the camera completely out of the bag.
- Determine the framing of the scene and decide if you have the right lens for the job. If not, change it now.
- Check the front element of the lens for snow, ice, dirt, or water drops. If needed, give it a quick wipe.
- Turn the camera on.
- Check the battery level and memory capacity. If either is too low, switch out the battery or card with a spare.
- Check to make sure the settings have not been accidentally changed: exposure mode, aperture, ISO, auto bracketing, autofocus, exposure compensation, and self timer. If you know your camera well, it shouldn't take more than a second or two to perform.
- Frame—take a moment to ensure you have the best possible composition—and shoot.
- Check the histogram for burnt highlights or lost shadows. If necessary, adjust the exposure compensation until a satisfactory image is recorded. If none can be obtained, consider bracketing for HDR imaging (see chapter 5 for more on HDR).
- If neither battery life nor direct sunlight on the LCD screen is an issue, check sharpness at 100%.
- Take your eye off the viewfinder, look around, and try to find other worthwhile pictures. Shoot even if in doubt.
- Once you feel confident you have done all you can, reset all the custom settings you may have used, putting the camera in a "neutral state."
- Turn the camera off, put it back in the bag, release the neck strap and the safety leash, and close the bag.

▶ *Next page: Battle of the Bulges buttress, Indian Creek, Utah. October 2009.*

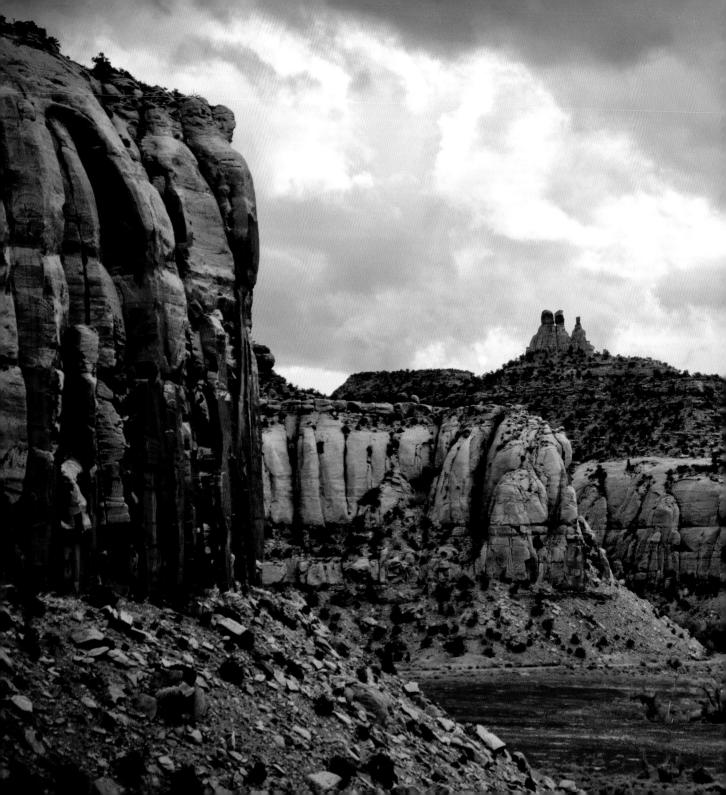

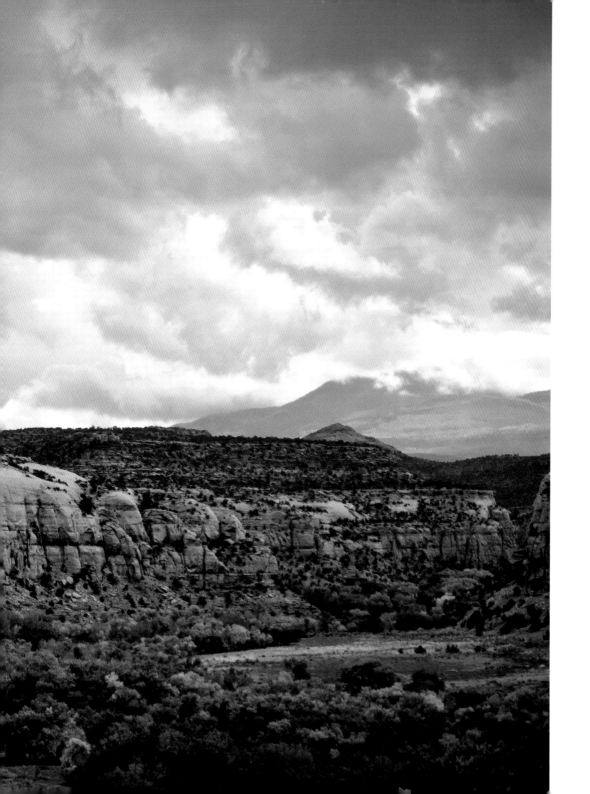

▲ *Rope team on the lower slopes of the central buttress of Stob Coire nan Lochan, Glencoe, Scotland. April 2010.*

Exposure

Obviously, all the usual rules of exposure apply in outdoor photography, and an underexposed climbing image will still be, well, an underexposed image. Knowing how to read a histogram is one of the most valuable skills a photographer can possess, especially in the mountains where it is often hard to see LCD screens well enough to accurately assess the exposure of an image. On the other hand, histograms are usually displayed with a high contrast, visible even in harsh sunlight.

Also, I would suggest taking photographs in RAW file format. RAW files give you much more latitude for correcting exposure errors than JPEG files processed in camera, and are thus preferred in almost all situations. Their similarity to film negatives also means that you can always come back to the old files and process them again with new tools and knowledge.

Snow

Snow is notoriously hard to photograph for a very simple reason. Camera meters assume that most scenes have roughly the same brightness, about 18% gray, and try to expose for that ideal value. But snow, because it is so reflective, actually appears much brighter. If left on their own, cameras will try to compensate by underexposing, so snow will appear gray instead of white.

Some modern meters, like the Nikon Matrix Metering system, are smart enough to recognize when snow is part of a scene and will compensate automatically for it. Otherwise, the solution is simple enough: Dial an exposure compensation of +1 to +2 stops whenever there is a substantial amount of snow in the frame. Again, knowing your camera will pay off. All cameras react quite differently to snow glare, and the only way to learn how to best expose snow is via trial and error.

ETTR

Under the barbaric acronym ETTR, which stands for Expose To The Right, lies a very important concept of digital photography. Due to the nonlinear way in which a sensor records light, the image file will contain a lot more information in the highlights than in the shadows. An optimal exposure then becomes one in which most of the details appear in the brightest zones of the image, without ever going overboard and becoming the pure white of burnt highlights. The histogram should still look like a traditional bell shape, but shifted to the right so that its extremity just touches the edge. The exposure is then dialed down in post-processing, bringing back all the details.

Several things should be noted before actually using ETTR, since it could be considered somewhat of an advanced technique. Only use ETTR if you shoot

in RAW format and care about getting the absolute best performance out of your images. Since all your photos will be overexposed by default, you will need to spend a considerable amount of time in front of a computer, fixing them one by one. You will also need to be extremely careful when shooting because it is very easy to overdo things and burn highlights, which will ruin the image entirely. To avoid this catastrophe, systematically evaluate the histogram.

High Contrast

Light in the mountains tends to be much harsher than in urban environments, leading to a new type of problem: When the contrast of a scene (i.e., the difference in luminosity between the darkest and the brightest part of the image) exceeds what the sensor of your camera can record, you will inevitably lose information. Concretely, this means that the histogram will be cut off at the edges, and that either pure white or pure black, if not both, is going to be recorded where there should be more details.

This phenomenon happens most frequently with landscapes that include both a bright sky and a dark foreground. Most cameras will give priority to what they think is the subject, resulting in burnt highlights and skies made of pure white.

If you find yourself in such a situation, you can try to correct the issue in several ways:

- First, ensure that the dynamic range of the sensor really is too small by adjusting exposure compensation (usually down) until you are certain that the histogram cannot avoid touching the edges.
- You should then observe the scene and decide whether you really need the lost details. For instance, an overcast sky will be so featureless that it won't really matter if it's recorded as pure white. Likewise, if the only dark parts of your image are small rock outcrops in a snow scene, it might be acceptable to let them appear entirely black.
- Finally, if you really need details at both ends of the spectrum, you will have to either use a graduated neutral density (ND) filter or HDR exposure bracketing. While the former has the advantage of not requiring additional post-processing, it is far less flexible than HDR and requires additional equipment. (For a more complete discussion of HDR, see chapter 5.)

▶ *Benoit Montagu on the sand dunes near Florence, Oregon. July 2008.*

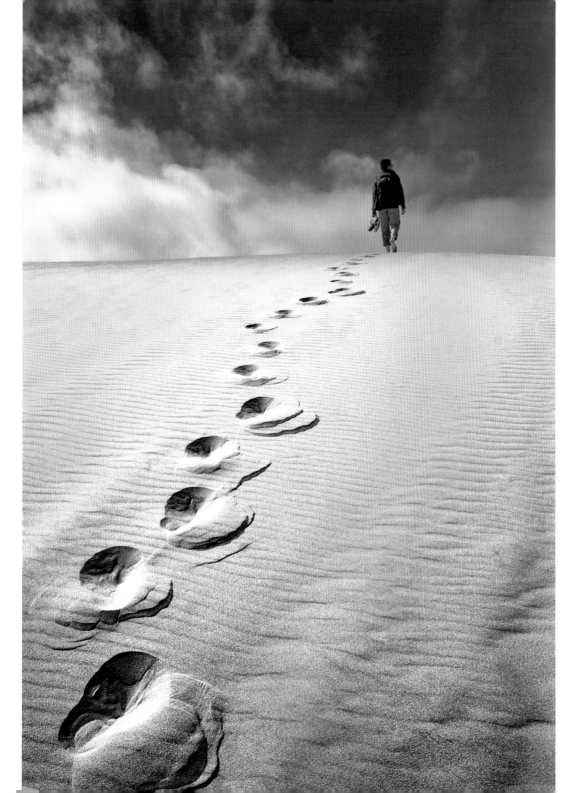

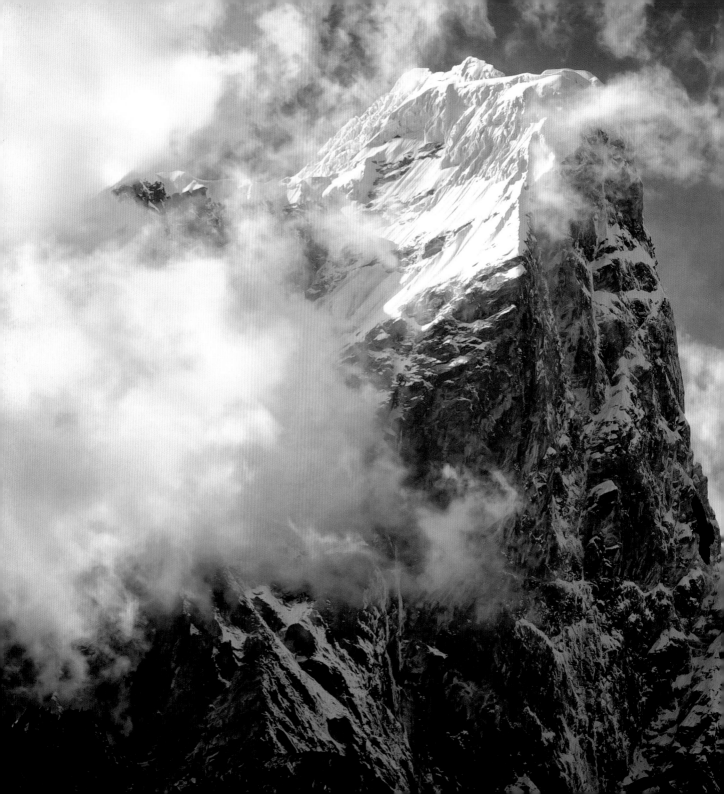

Creating Powerful Images

Chapter 3

A large portion of this book has been dedicated to selecting the right equipment and other technical issues. Countless other books, magazines, and online articles also review these subjects in great detail. The reason for this imposing presence is simple enough: of all the elements involved in the creation of an image, they are the easiest to quantify and discuss endlessly. Ultimately, though, they are also the least relevant. After all, even if you bought the most expensive equipment and spent years practicing exposure and focus, you could end up with images that are technically sound, but not necessarily interesting or inspiring. The ultimate goal should be to master photography technique and understand your equipment so using them is second nature to you, allowing you to instead focus on what really matters: the creation of a compelling and powerful image.

▶ *Sonnie Trotter photographed by Andrew Burr on Air Swedin (5.13 R), Indian Creek, Utah. October 2009.*

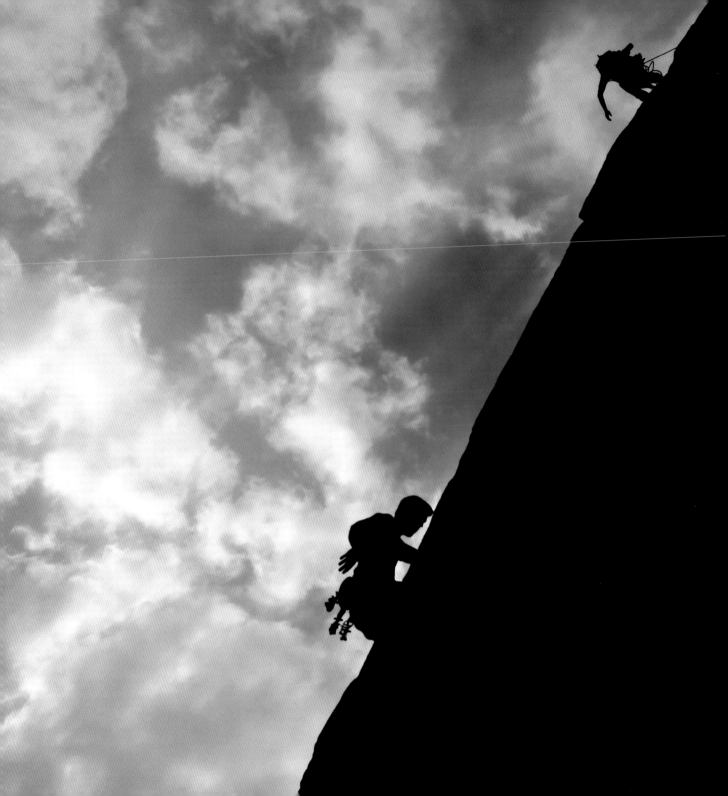

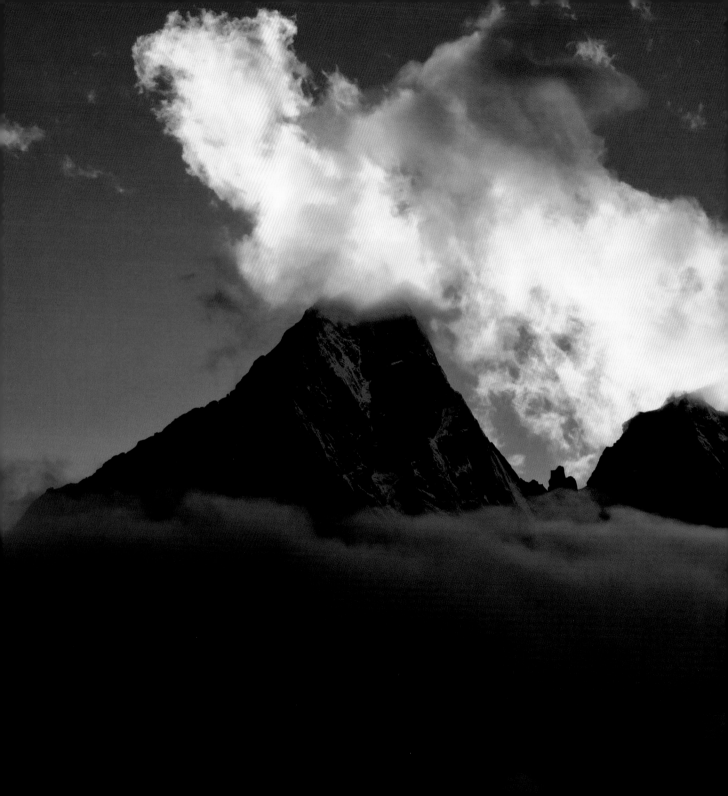

Sunset on the sacred mountain Khumbu Yul Lha, Nepal. October 2010.

Be Inspired

While I agree there is no recipe for good photography, I should also say that most great images do share a common ingredient. More than luck, raw talent, hard work, experience, or equipment, what really makes a difference in the quality of a photograph is that the photographer deeply cared about the image when he created it. The creator of the piece had something to say, and photography was his chosen medium. The artist may not have cared about the immediate subject (I doubt Edward Weston was that passionate about peppers), but at some level there is a message in each timeless photograph. In a way, this next statement is almost a tautology: a good photograph is one that is inspiring, and it can't be inspiring to viewers if it hadn't been inspiring to the photographer when he pressed the shutter release button.

If you want to create powerful images, the first and most important step is simply to care about your images. You need to have something to say, and you need to express it through your photography. You already have something substantial to offer viewers, you love the outdoors enough to leave the comforts of urban life, and you want to share your experiences with others by becoming a better photographer.

Every time you are about to take a picture, ask yourself how the scene you are photographing makes you feel, and whether the image you are about to create is the best way to express that feeling. Are you awed, amused, scared? Is this a tale of suffering, of conquest, of brotherhood, of humility?

Just remember to ask yourself this question: If you don't care about your subject, why should any viewer? Or, if you don't care about your subject, why would you care about producing a good photograph of it?

A few years ago, on a hike in Swedish Lapland, I saw a postcard with a waterfall in front of an easily recognizable mountain. As I walked back to camp, I happened to pass that very same waterfall in similar lighting conditions. For some reason, I felt that I had to take the same picture. The print turned out pretty well and had some success with viewers, but deep down, I always hated it. It wasn't mine. I wasn't expressing anything with it. Shortly afterward, I deleted it from my portfolio.

▶ *Sunrise on Nevado Huandoy from the summit of Nevado Yannapaccha, Cordillera Blanca, Peru. June 2009.*

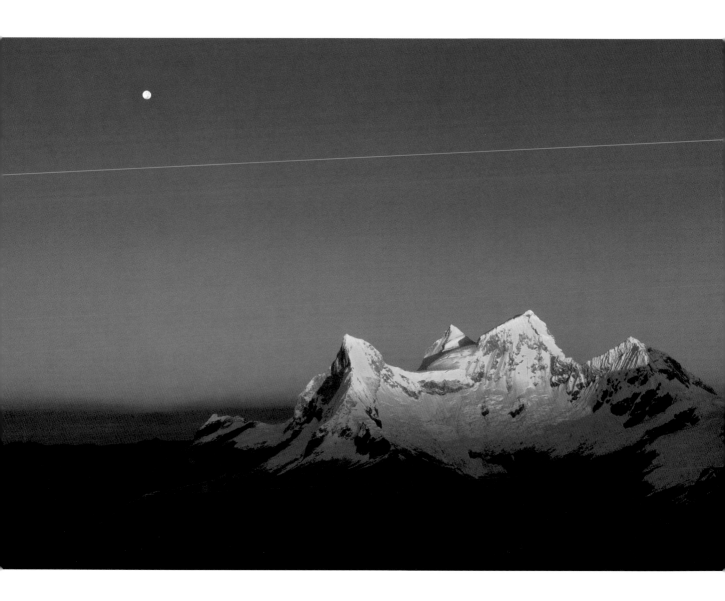

Quantity vs. Quality

The issue of shooting quantity is a surprisingly sensitive one. Two contrasting attitudes can be found: on one end of the spectrum, *the machine gun* photographer will shoot indiscriminately at everything and everyone fortunate (or unfortunate) enough to pass in front of his lens, the hope being that such a heavy volume of shots will give the photographer a statistical advantage, increasing the odds of accidentally creating a masterpiece. On the other end, the *master craftsman* will approach each subject with the utmost caution, eyeing it under every angle, taking every factor into consideration before finally, almost reluctantly, setting up the camera and shooting a single, perfect frame.

At first glance, the master craftsman seems to be placed on a higher plane, his approach an ideal toward which we should strive, but I would like to argue that using the machine gun approach may be worthwhile, especially for outdoor photography. Here are some advantages to shooting a lot, even in situations unlikely to produce great images.

- It will give you mileage. Just like in climbing, there is no shortcut: to be a good photographer, you have to shoot a lot, day in and day out. By accumulating frames, you will gain experience. You will also be able to experiment, try new ideas, and gain a better knowledge of what works and what doesn't.

- If you experiment a lot and keep shooting even when you wouldn't expect to yield good images you will occasionally stumble upon hidden gems—pictures you wouldn't have created otherwise. You shouldn't rely on those rarities for the bulk of your portfolio, but rather consider them as icing on the cake. After all, lucky accidents *do* happen.

- Shooting a lot breaks an important mind barrier by making you realize that you are not obligated to produce a masterpiece each time you press the shutter. Go through the contact sheets of Ansel Adams, Robert Doisneau, Galen Rowell, or any of your photographic heroes, and you will find that—just like everyone else—they shot heaps of bad and average photos. You might even try shooting a few dozen semi-random frames in the morning to warm up and get rid of unreasonable expectations.

- As mentioned already, in hiking or climbing photography, photo opportunities are both unique and short-lived. It is often difficult to judge on the spot how a photo will ultimately turn out, so why not shoot if you have any doubt rather than missing a potentially good image?

▲ *Tibetan prayer flags on the bridge between Namche and Monjo, Khumbu, Nepal. October 2010.*

- Sometimes, you simply don't have the time to make sure you are capturing the perfect image. When on a difficult climb, I often shoot all the possible different compositions of a scene rather than take the time to decide which is best.
- Finally, all the images you take, even the ones of relatively poor quality, will be great memories of your trip.

Of course, there are also downsides to being trigger happy. An obvious, albeit minor disadvantage is that you will use more disk space and need more memory cards. Since memory cards are relatively inexpensive, this factor shouldn't be too much of an issue. But you should still consider the implications of using more memory.

Another drawback is that you will have to do some heavy editing. You will need to go through dozens of similar photos and select the best one or two, a harder task than it may sound. Good library management software and strong self-discipline will be essential. Depending on your workflow and your storage setup, you may need to delete the less interesting variations of a same scene while you are still out in the field. Of course, it is acceptable to do this task as long as you are completely sure you have better images in store, but such a certainty is hard to obtain in the outdoors.

The real objection put forth by most critics, however, is the often justified fear that shooting a lot replaces critical thinking and is only masking the photographer's laziness of finding the optimal viewpoint for a scene. You will need to be honest with yourself and consider whether shooting a lot is really a tool to help you develop your creativity or merely a crutch on which you are relying too much.

A balance has to be achieved between the two positions. As long as you can honestly say that you are not completely replacing quality with quantity, you can shoot photos that you know are unlikely to be exceptional.

▲▶ *I set up the tripod and took this first shot, but after I stood up, I found a totally different scene simply by turning around, as shown in the second image. (Teusajaure along Kungsleden, Lapland, Sweden. August 2007.)*

Composition

Entire treatises have been written on the surprisingly complex subject of how to arrange elements inside the frame. Studying them can prove useful, especially for the more analytically minded among us, but some might simply prefer to observe the works of photography or painting masters.

In the mountains, just like everywhere else, the usual rules of composition apply, and this book wouldn't be complete without mentioning the most common of them:

- The rule of thirds affirms that putting the subjects slightly off the center makes the image more dynamic. Some argue that better results can be achieved when using the golden ratio (1.618) to determine where to place the subject rather than dividing the frame into thirds and placing the subject exactly at the 1/3 mark, but the jury is still out.
- You can direct attention toward a subject by using color and light judiciously. Contrasting colors attract the eye — so do bright areas, which explains why a common processing trick is to add extra vignetting (darkening of the edges) to direct the viewer to the center of the frame.
- Strong shapes and lines in a composition, especially triangles and diagonals, are dynamic and direct the eye toward a specific point. Positioning the subject at the intersection of strength lines is a powerful way to attract attention to that subject. Natural frames (tree branches, arches, etc.) can also highlight a subject.
- The edges of an image are a sensitive area, and you shouldn't put anything too prominent in that part of the frame, lest the eye be tempted to wander out of the picture altogether. You should also avoid cutting an object off at the edge of the image.
- Out-of-focus backgrounds are important. Backgrounds should contribute to the story of the photograph but not steal the show. The focus should point to the important parts of the image.
- Whenever a subject is moving or looking in a direction, leave plenty of space in the image to allow the viewer to participate. For instance, if a hiker is walking toward the right, he should be positioned close to the left edge.
- The simpler the composition, the stronger the image. Complexity is distracting. An ideal image has all the elements needed to understand the story and nothing more. To quote Thoreau: "Simplify, simplify."

The previous list is a pretty standard one. You will find some version of it in half of the photography books in the library. However, its usefulness should not be overestimated. While it can be used as a checklist and will occasionally help you make a decision, it cannot be a recipe for good composition, and exceptions to these rules tend to be almost as numerous as the good examples. Perhaps, "rule" is not the right term, and these points could better be described as "properties shared more often than not by images generally judged as good" (though something has to be said for brevity).

More importantly, through experience, by shooting thousands of images and seeing thousands more, both good and bad, you will develop instincts of what, to you, constitutes a good image. Rarely does a photographer consciously think, "I should position my subject at the intersection of those strength lines." She will just instinctively do it and maybe, afterwards, realize that her image works because of it. In this sense, the list provided above may be more useful to the art critic than to the photographer; though to the beginner who hasn't yet shot enough images to have gained this instinctive knowledge, it can be an adequate replacement.

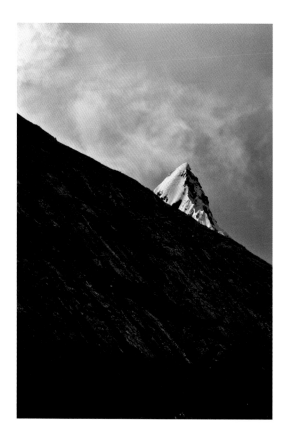

▲ *Nevado Quitaraju viewed from the Santa Cruz valley, Cordillera Blanca, Peru. June 2009.*

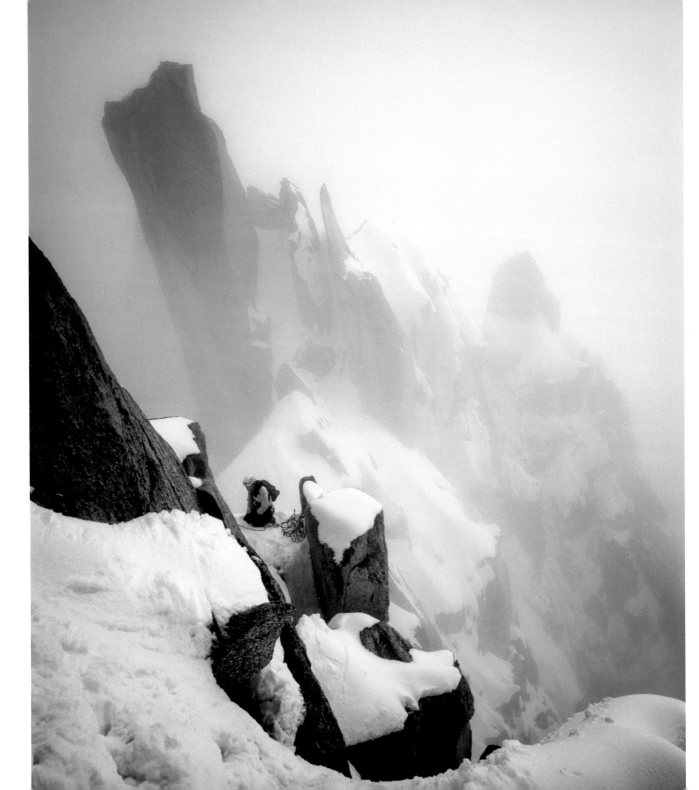

The Story

Paradoxically, even though hikers and climbers wander among some of the most beautiful places on the planet, the question of what exactly to shoot is a very difficult one. Too often, hikers come back with amazing memories but only a few shots of the mountains, which lack interest. Climbers have a slightly easier time producing good images, since action shots are more common, but entire memory cards are often filled with butt shots and uninspiring piles of scree.

Before one can even think about composition (i.e., how to arrange the elements inside the frame), the first task of the photographer is to find a worthwhile subject. The best way to do that is to figure out which story you want your image to tell. The single most important characteristic of a good image is that it has a message. It doesn't have to be a complex or deep story, but it should be something that *you* want to say and that you really care about. Your story could be about virtually anything: how wild (*a condor flying away in a canyon*), hostile (*your camp in a snowstorm*), big (*a minuscule rope team in the middle of a wall*), beautiful (*sunrise over the whole range from the summit*), or inspiring (*sunset above camp*) the mountains are. It could be about how difficult (*an exhausted hiker with a big backpack*), dangerous (*a climber looking down on several hundred feet of air*), painful (*a closeup of your partner's frozen face*), or scary (*a climber high above his last piece of protection*) what you are doing is. It could be about how much fun you are having (*someone's leap of joy on the summit*); how simple pleasures are what really matter (*a pot of fresh coffee in the morning*); how admirable the local mountain people are (*porters carrying heavy loads on a rough trail*); how small things are also important (*a closeup of a flower in front of a rock face*). Or you could photograph a thousand other things that matter to you.

Though making your images have a message to share with the viewer is very important, it will rarely be a conscious process. There is a good exercise if you are having difficulty figuring out exactly what story your image tells, or even if there *is* such a story: put the image into words. By simply describing an image, it should be clear whether or not something interesting is going on. For instance, if the best description you can come up with is, "This is a photo of a mountain above the trail," you might as well delete the image on the spot. But if instead you say, "This is a photo of a mountain shrouded in clouds and looking mysterious," then you are onto something. An even better description would be the following: "This is a photo of a mysterious-looking mountain partially

◀ *Climber on the upper part of the Arête des Cosmiques, Chamonix, France. June 2010.*

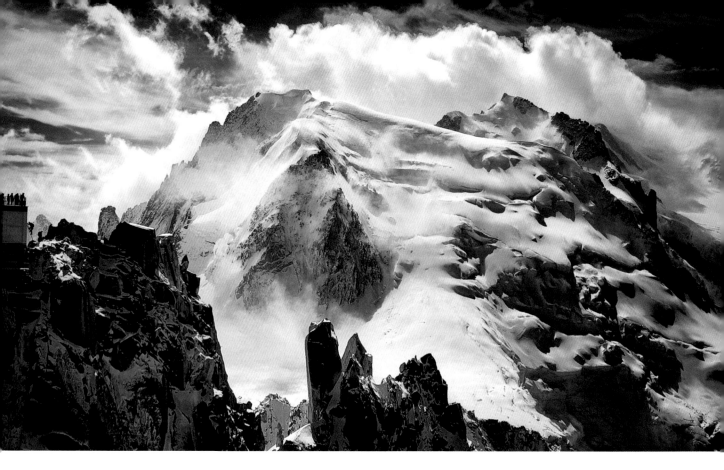

▲ *The north face of Mont Blanc du Tacul and Arête des Cosmiques, Chamonix, France. September 2008.*

covered in clouds, and the occasional glimpses of rock and snow suggest its size is absolutely massive. A hiker in the foreground provides a counterpoint by appearing very small."

However, the point of this exercise is to *describe* what you see, what is actually present in the photograph, not to *explain* the story with extra information that doesn't show in the image. Your photos should always be able to stand on their own, or they will fail at delivering your message.

More Practically

Having discussed the so-called theoretical side of how to choose your subjects while in the mountains, now here is some more practical advice:

- Learn to see light, and treat it as a subject in its own right. Warm, low-directional morning or evening light outlines depth and creates gentle contrasts that are particularly pleasing. Conversely, the harsh and flat light of the middle of the day is very boring in photographs.
- Move around as much as possible in your search of the optimal point of view. This movement can occur both in space and in time, and waiting for conditions to evolve can often tremendously change the character of a scene.
- Observe the weather, and make it another one of your subjects. Clouds are often the key to making mountains look really interesting. For instance, few things look as threatening as storm clouds on the horizon, and such foreboding elements often produce a strong story.
- By definition, mountains are vertical environments. Emphasize their height whenever possible by exaggerating perspective.
- Natural scenes tend to have a fractal character, meaning they look the same at any scale. As any hiker knows, accurately judging distances in the

▲ *Gareth Candlin in front of Tryfan, just after having climbed the mountain via Grooved Arete (HVD, 240m), Snowdonia, Wales. March 2010.*

mountains is often very difficult. For this reason, if you want to show the scale of the mountains, you will need to include known elements in the frame, such as trees or humans.

- Whenever shooting action, you need to get the timing just right, catching the subject in the middle of the action: an ice climber swinging his tool, a rock climber clipping the rope, a hiker jumping over a river, etc.
- Don't forget to pay attention to the backgrounds, even if they are out of focus. Moving a few meters to simplify a background can sometimes make all the difference in an image.

- Remember the reason you ventured outdoors in the first place. Whenever shooting people, try to place them in their environment. Unless you are specifically doing portraits, shoot wide to include trails, rivers, and mountains.
- You'll be tempted to only shoot the sweeping vistas, but think about all the other genres. You could document the local customs; you could do a photojournalism report of the expedition; you could photograph closeups of the flora, abstract details of the rocks, or intimate portraits of your companions, etc. Keep your options and your mind open.
- Before leaving home, you may wish to prepare a short list of images you really want to bring back, but don't let it block your creativity, and constantly be on the lookout for original points of view.

Finally, you should forget everything mentioned in this chapter. Experiment. Break the rules. Develop your own style. Trust your instincts.

▶ *Chongba Sherpa and Chris Jones trekking below the south face of Lhotse, the fourth highest mountain in the world. Khumbu, Nepal. October 2010.*

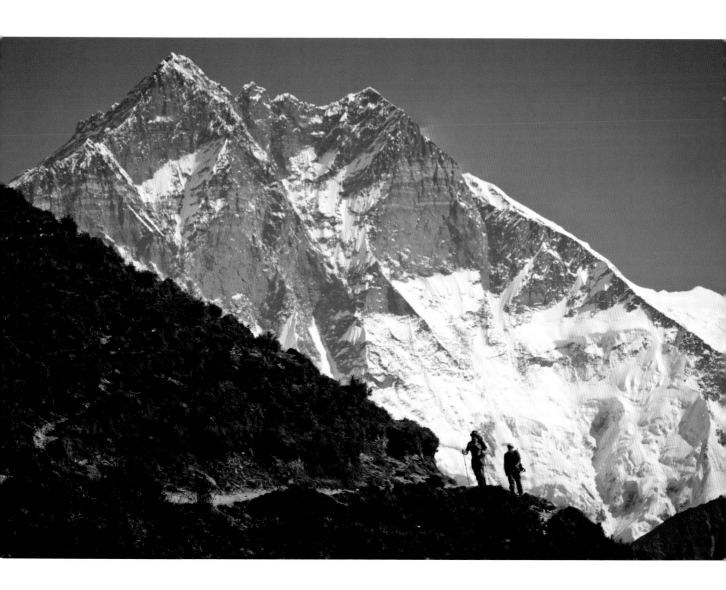

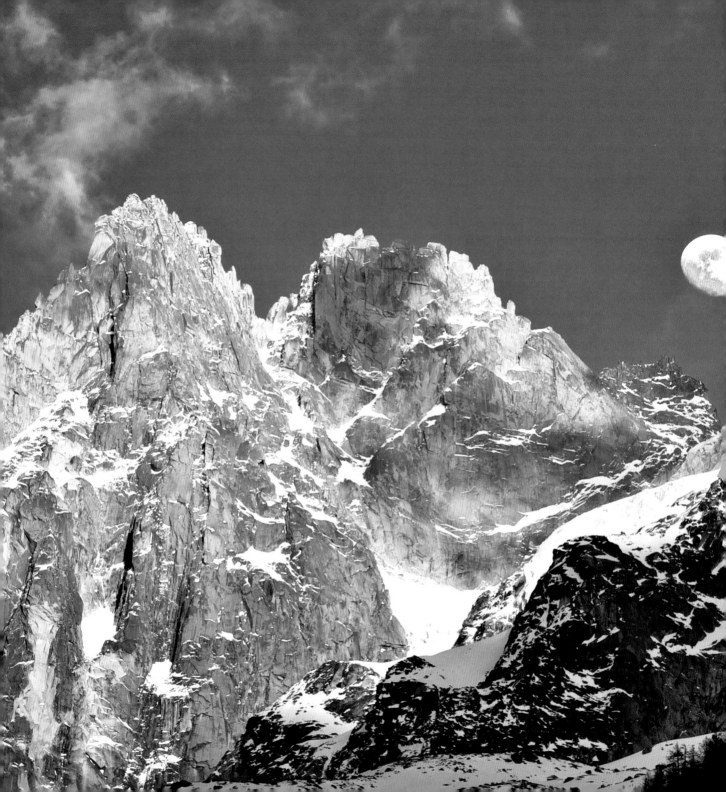

Discipline Specific

Chapter 4

All of the photography tips we have discussed so far could be applied to various outdoor activities, especially hiking, rock climbing, and mountaineering. But despite all that climbers and hikers have in common, they face different challenges, and the best way to photograph their respective disciplines can vary a great deal.

For clarity's sake, this chapter will be divided in four domains, though boundaries are often blurry and there is, of course, a lot of overlapping between the disciplines.

- Camping is practiced by all outdoor enthusiasts and simply refers to the act of spending a night in the outdoors, far from a city. Campers sleep in tents, open bivvies, or mountain huts.
- Hiking is the act of travelling along relatively easy terrain that does not usually necessitate a rope for safety. In this category, I would also include scrambling, supported trekking, fell running, and easy winter walking.

- Technical climbing refers to roughly vertical climbs on fifth-class terrain. Unless you are bouldering, you will be using ropes. This type of climbing requires a smaller time commitment, and the routes are relatively easy to access. This category includes bouldering, single pitch climbing, and short multi-pitch climbing on rock and ice.
- Finally, mountaineering corresponds to long and technical routes in the mountains. This type of climbing requires a significant time commitment and the routes are usually difficult to access. It includes big wall climbing, alpinism, and winter climbing.

▶ *Will Foreman belayed by Rune Bennike on The Rasp (E2 5b), Higgar Tor, England. June 2010.*

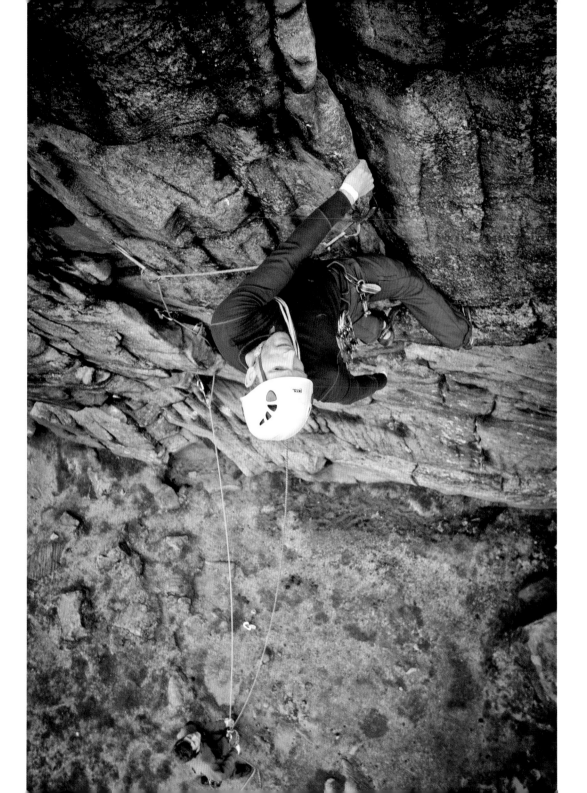

Camping

On almost all expeditions, regardless of difficulty level, you will need to spend a couple nights in the mountains. The comfort levels of the various available accommodations vary considerably, from three-star mountain huts with showers and electricity to hanging bivvies in the middle of a north face. But in almost all cases, camping time is an opportunity to relax, rest, and reflect on the achievements of the day. It is also often your only period of free time, which makes evenings and early mornings perfect opportunities for photography. These are the moments when you can liberate your mind from the preoccupations of the day. Additionally, as any decent photography book ought to mention somewhere, you often find the best light at those hours; when the sun is low, creating a warm, lovely depth and gentle contrast.

On the other hand, you may be tired from a long, arduous day, wishing little more than the basic necessities of food, warmth, and sleep—which is not the best condition to be in when engaging in an activity that requires focus and dedication! You will also have stopped moving, and your companions will be performing less visually interesting tasks, which means you will need to work harder to create original and engaging compositions. For these reasons, few photographers spend effort on photography while in camp, but those who do are often rewarded.

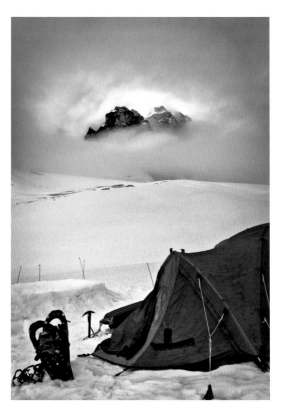

▲ *Camp 1 on the Pica glacier, below the summit of the Trolls, Little Switzerland, Alaska Range. August 2008.*

Once you have decided that you have enough energy left for photography, your first task is to examine your surroundings and make a mental note of the

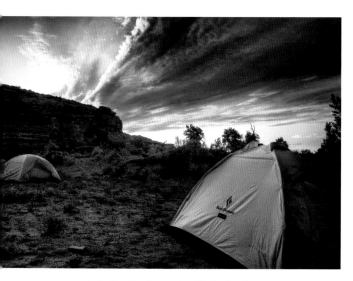

Indian Creek camping, Utah. October 2009.

elements that could be potentially interesting, either as subjects or as backgrounds. You can usually predict roughly how evening light will look on the different mountain faces and where it will disappear first. Take a few shots to check your compositions, but always make full use of the luxury of time and wait for the best light. If it is early enough, you could also take a short walk to explore different points of view.

Getting good images of a campsite can be surprisingly difficult, but a good rule of thumb is to keep things simple. The less you include in the frame, the more powerful your composition. A single tent in front of a mountain carries a much stronger message than a dozen tents with the same background. If you want to capture the life of camp, a shallow depth

of field* is key, as it will focus the eye on the action being performed, hiding the distracting, brightly colored fabrics and backpacks.

Camping also provides you with unique night photography opportunities: headlamp trails, campfires, starry skies, or even, if you are lucky enough, the northern lights. (See chapter 5 under "Low Light and Night Photography" for a more detailed discussion of the specific challenges you might face when light disappears.)

Sunsets are one of the most commonly photographed subjects, yet sunrises tend to receive very little attention. If you are disciplined enough to get up early (for me, rising early is often the crux of any alpine route), you will often be repaid with unique and gorgeous light. On some expeditions, rising before everyone else may be the only opportunity to spend some quality time focused on photography.

A shallower depth of field can be obtained by, in order of importance, longer focal length, reducing the distance to your subject, increasing the distance between the subject and the background, and opening your aperture.

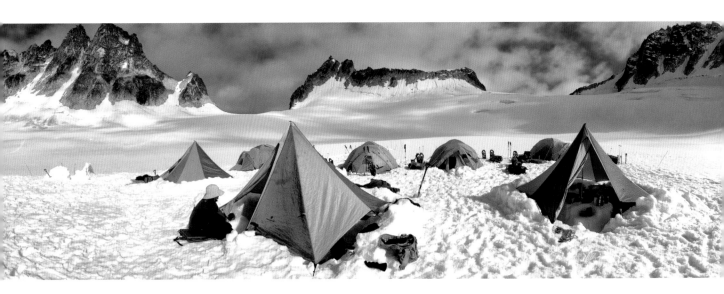

Finally, evenings are also a good time to reflect on the day, review your captures (if your battery levels allow it), perform any needed backups, and check your gear to see if it needs maintenance. During these hours, self-discipline will pay off, as it is far too easy to skip any of these tasks, only to regret it bitterly the next day. It goes without saying that photography should never be an excuse to escape your camp duties—though it could be worth negotiating with your partners for allowing you to do your chores only after the best light has disappeared.

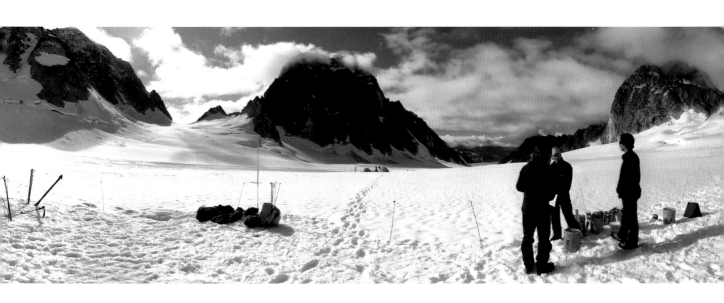

▲ *360° panorama of Camp 2 on the Pica glacier, Little Switzerland, Alaska Range. August 2008.*

Hiking

By our very definition, hiking is the easiest of the three different outdoor disciplines, since it is mostly a physical challenge requiring few technical skills. Unrestricted by a rope or by rock-fall danger, you will have much more freedom to move around, stop, and explore your surroundings. You will also be able to spend more time focused on your photography, thinking about your light, composition, and subject.

On the down side, hiking scenes can lack visual drama, and the immediate environments tend to be flatter and less impressive than climbing environments. You will have to construct images that work around these issues. For instance, you could focus on the physical challenges and strain facing the hikers rather than on the dangers of the terrain.

Try to always be well prepared. First, with a map or a guidebook, you can generally get a fair idea of where the path will take you. Add to the equation the quality of light, time of day, and weather forecast, and you should be able to make some educated guesses as to where the best photo opportunities are likely to lie. Next, build your image backwards: look for interesting backgrounds (e.g., mountains, lakes, or valleys), and then add an equally interesting and contrasting foreground (e.g., the hiking trail, the lakeshore, a running river, or simply a lone tree). Decide whether or not you want to include human figures in your image

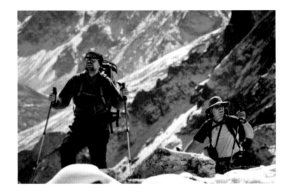

▲ *Mark Howard and Norrie Rodgers reaching Lobuje East high camp, Khumbu, Nepal. October 2010.*

and decide what role they should serve: Should they be the focal point of the image? Or should they simply serve as a reminder of how small humans are and how majestic the natural environment is?

One very effective way to create good hiking photographs is to place other hikers against a distant background that is thrown out of focus. For this method to work, you will need to shoot from a lower position, such that the hillside immediately next to the hikers does not show, which usually means that the path either has to take a sharp turn or follow a ridge. A good map will tell you exactly where these sites are located, so study it carefully before the day starts.

▲ *Maeva Buisse and other hikers descending Nevado Chachani, Arequipa, Peru. October 2007.*

When taking pictures of your own hiking party, you will probably be tempted to simply fall behind and shoot the backs of your partners. This technique can work well to convey a message of determination, to show someone working toward a goal (e.g., reaching a mountain), and such images tend to be very graphic. On the other hand, they do not show the faces of your subjects. Faces create very powerful photographs, for it is through them that we most often connect and empathize with other human beings. You might wish to run in front of your party and photograph them until they have caught up; these images will focus more on the humanity of the hikers. In any case, assuming that it is safe and you are allowed to do so, you should never hesitate to step off the path and try to discover unique and

interesting viewpoints. This positioning will often be the only way for you to incorporate all the elements into your ideal composition, and it will also allow you to use the path as a subject in its own right.

If you are walking alone and you find yourself in desperate need of a human element in your composition, a makeshift, stable platform and a self-timer make it fairly easy to include yourself in the composition. When you frame your image, find some reference marks that will help you recognize where you should stand, start the timer, and then make a run for it. Try not to take an affected pose, and avoid looking directly into the lens. Be aware that it may take a few tries and many expletives to get things exactly right.

> *But watch your step! The photo subject who keeps stepping back and finally falls off a cliff might be a comedy classic, but the 19,931-foot summit of Nevado Chachani has a cross to commemorate the British climber who made that very mistake.*

Whether you are carrying a huge expedition pack or a tiny daypack, your camera should be readily available from the moment you set off in the morning until you retreat to your tent in the evening. Keep it on the outside of your bag. You never know when the next photo opportunity will arise, how long it will last, or whether it will be convenient (or even possible) to find your camera equipment from the depths of your pack. If you are going on a supported trek, you should be especially mindful of what you send along with the porters or mules, as they will rarely walk at the same speed as the hikers during the day, and most likely, you will not be able to retrieve anything from your main pack before reaching the new camp.

Karin below Geàrr Aonach, Glencoe, Scotland. April 2010.

Norrie Rodgers trekking above Chukhung, in front of Taboche, Khumbu, Nepal. October 2010.

Andreas having lunch on the trail, Kungsleden, Lapland, Sweden. August 2007.

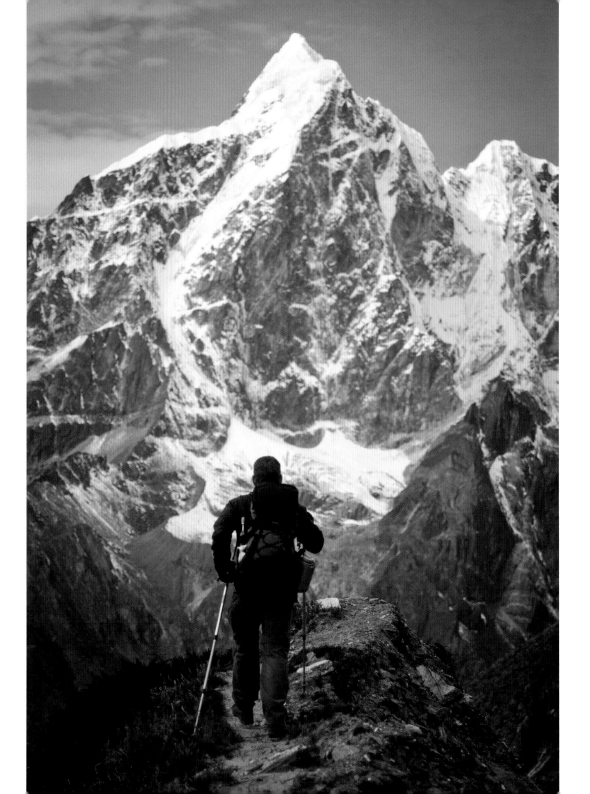

Technical Climbing

One of the main differences between technical rock climbing or ice climbing and the other photography disciplines discussed in this book is that you will not be a full participant in the action you are shooting. Instead, you will be focusing entirely on your photography, and you will be able to gain control over many factors of the shoot. On the flip side, this task will require dedication, as climbers are usually reluctant to sacrifice climbable time, even to a noble task like photography.

In technical climbing photography, more than in any other kind of outdoor photography, perspective is the most important element of composition. If the viewer can't understand in a glance the verticality of the environment, then your image loses most of its impact. The key to emphasizing perspective is to always shoot from an interesting point of view, most often straight above the climber. Showing the real angle of a rock in a photograph can be very difficult, especially if it is overhanging, but free-hanging items (e.g., quickdraws, chalk bags, and long hair) can provide your viewer with useful clues. Also, use the orientation and aspect ratio of the final image to your advantage. When shooting from above, a vertical orientation tends to help perspective by directing the gaze from top to bottom instead of from left to right. Tilting the camera slightly can also help communicate how steep the rock is.

In order to tell a good story, your image will almost always have to show the face of the leader, which means that you will have to anticipate her movements and shoot whenever she looks up or to the side. Be especially wary of armpit shots, which are far too common due to the nature of the sport. Other important elements to include in some of your compositions are a climber's points of attachments to the wall: hands and feet. If you can make it obvious that the climber is putting her entire weight on two dime-sized holds, you will give your viewer an idea of how difficult the climb is.

Of course, you still need to pay attention to your backgrounds. You can use a shallow depth of field to remove distractions, or a wide composition to place the climber in her environment, showing off the vertical cliffs or the nice landscape in which she is now a part. If you are shooting from above, you will have the opportunity to include the ground or the belayer in the frame. This possibility can lead to interesting compositions, but for it to really work, the climber (subject) should already be relatively high on the rock face, and the belayer (background) should be paying attention (which means looking up), something few belayers actually do most of the time.

▶ *Raymond Gaétan on Les Ailes du Boffi (F7c), Gorges du Boffi, France. April 2010.*

When cragging, the ground is also often a big mess of gear, food, ropes, and packs, and tidying up before you set off to shoot might prove worthwhile.

The last important element of any good climbing image is action; something interesting needs to be happening. Capture a climber completing an impressive move, placing or clipping protection, chalking up, or simply wearing a suggestive facial expression. Knowing the route and being a climber yourself will be very helpful in anticipating the next action, but remember that climbing photography remains fast-paced action shooting: don't be ashamed to fully exploit the burst mode of your camera!

Many viewers think that the only images worth contemplating are those showing a leader above her last piece of protection. Shots in which the climber is seconding (following) should ideally be reserved for mountaineering photography, where access to a good point of view is often too time-consuming. Top roping shots are usually just plain boring because all drama is removed from the scene. Even people who have never climbed before usually figure out what would happen if the climber should fall, and they realize that leaders play a much riskier game than top ropers.

Accessing good points of view often means ascending a fixed rope. This is an advanced and dangerous technique that is well outside the scope of this book and deliberately not detailed here. Seek proper instruction before attempting to use this technique, and remember the safety basics: all systems should be made redundant, your anchor should be bomb-proof, your gear checked, and inspected by someone else if possible. Practice jumaring a lot, in a gym or another safe place, as you need to be able to go faster than the climber—a harder task than it may sound, and a nearly impossible one if you use prusik knots instead of handled ascenders.

Besides watching out for your own safety, the golden rule is to *never*, under any circumstances, get in the way of the climber. Missing a photo opportunity is a small price to pay to avoid disturbing a leader, and there is no faster way to lose goodwill than to make someone slow down or fall. Most people will not mind being photographed during their ascents, as long as you remain out of the way!

You will likely spend a while hanging in your harness, and your comfort while wearing one should be a priority. You should especially pay attention to maintaining circulation in your legs. Invest in a well-padded harness, and ask big wall climbers for their experience on how to endure long hanging belays. On overhangs, a chest harness will help you stay upright and control your orientation. You may wish to clip yourself into intermediate protections to reduce

▲ *Rune Bennike on Great North Road (HVS), Millstone, England. June 2010.*

swinging, which may also help you get out of the way of the climber. Be creative: either bring your own removable protection or use bolts from an adjacent route.

As soon as you reach a position from which you want to start shooting, back up your ascenders and coil the rope hanging freely down, attaching it to your harness so that it doesn't show in your pictures. Be equally wary of your own shadow, as you don't want it to cast into the frame or across the climber. During some times of day, this is unavoidable, and it might not even be worth turning your camera on!

If you cannot or do not want to ascend a fixed rope, you have some other options, but your goal should always be to avoid the dreaded butt shot. Shooting from the base of the climb often leads to boring images, devoid of human faces and steep-

looking rock. You will have to think creatively to gain a good vantage point: boulder up a nearby ledge and shoot the climber's first moves, or position yourself far away and show a tiny climber on a big cliff. Walk around the climb and shoot from the very top of the wall, or ascend another route and use a long lens to compress perspective. You can also choose to focus on the details: gear, hands, faces, or feet.

Finally, whenever you shoot unknown climbers, try to make a habit of getting their names and contact information, as well as the details of the route and its grade, as this information is nearly impossible to find afterwards. Offering to send them your pictures (and actually doing it) will go a long way and win you some new friends.

▶ *Gareth Leah on Comes the Dervish (E3 5c), Llanberis, Wales. July 2010.*

Mountaineering

At the crossroads of hiking and rock climbing, mountaineering presents more challenges than any other outdoor activity described here, combining difficulty of access with vertical ground necessitating a vast array of technical skills. On the other hand, you can get action shots in the most beautiful environments on the planet! The composition advice from the previous sections all apply: show the surroundings of your subjects, show the scale of the mountains, show the mountaineers' faces, and show your subjects performing interesting actions.

You can obtain good images much more easily when climbing in teams of three or more, as you can be relieved of climbing and belaying duties, but reaching an interesting point of view will be more challenging than ever. With enough time, a pitch can be led twice, the first ascent fixing a rope for you, but you will rarely have that luxury. In most cases, you will have to photograph either your second (the person following you)—not the most aesthetically pleasing choice but an often acceptable option in the mountains—or the butt of the leader at the start of the new pitch. If you are belaying at the same time, you need to be using an auto-locking device or tell the climber that she will be off-belay for a few moments (something that should obviously be reserved for very easy ground).

The easiest way to get good mountaineering action images is often to photograph another party. They could be a long way away, making it worthwhile to have lugged the long lens, or you could be climbing in several parties of two or three. In that case, the best position for you is as second on the first rope, asking the leader of the other team to follow you as closely as possible.

To be realistic though, climbing will probably take all your energy and focus, and it will be far too easy to entirely forget about photography. You will need to make the effort to look for good photo opportunities. If at any moment, you think that a photo break would be inconvenient but could lead to a good image, then (mentally) self-kick your ass and do it! But always keep your safety and that of the other members of your party in mind at all times. As discussed in previous chapters, having your gear easily accessible will really pay off. Try to make the whole process of shooting as fast and painless as possible.

For example, in alpine starts when the new day dawns, it is easy to make excuses about light levels being too low, instead of bumping the ISO up and dealing with noise later. Similarly, when the weather takes a turn for the worse, see it as an opportunity to create truly unique images rather than a reason to stop shooting. Remember why you are a

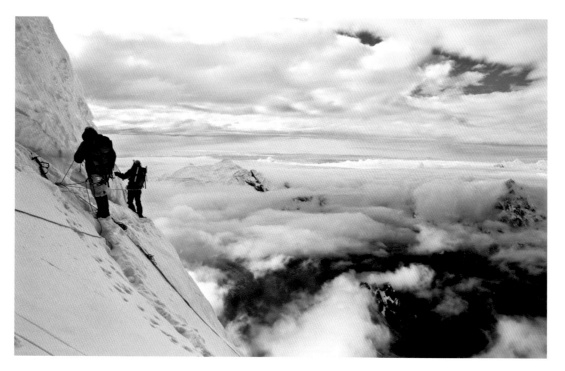

▲ *Percy Dextre on the exposed crux of the southwest ridge of Nevado Chopicalqui, Cordillera Blanca, Peru. June 2009.*

mountaineer in the first place. Sure, it would be easy to turn the camera off and keep climbing, but then again, it would be even easier to stay in a warm bed back home.

▷ *Xavier Vaillant skinning up the Périades, Chamonix, France. February 2010.*

▷ ▷ *Rope team on the summit mushroom of Nevado Chopicalqui, Cordillera Blanca, Peru. June 2009.*

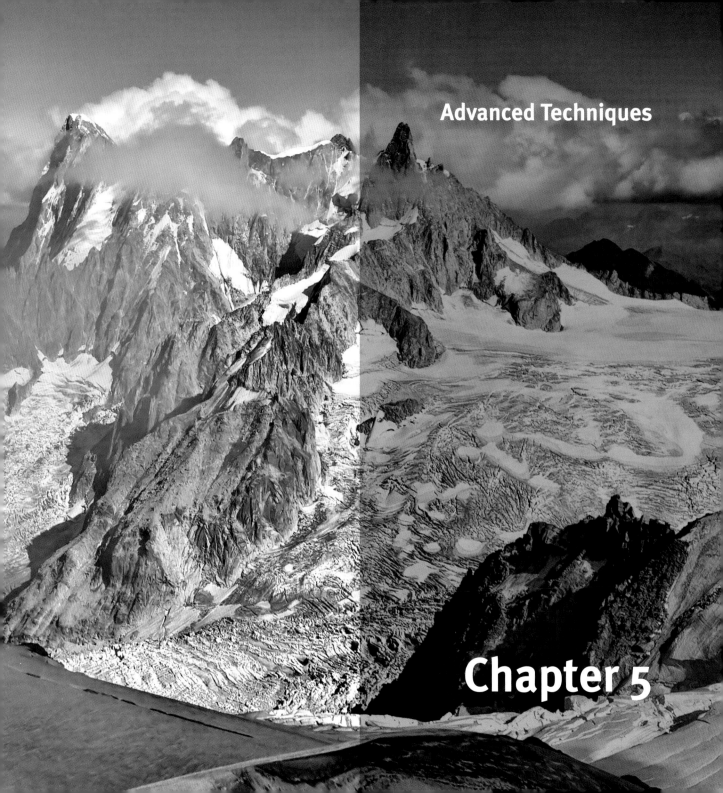

Advanced Techniques

Chapter 5

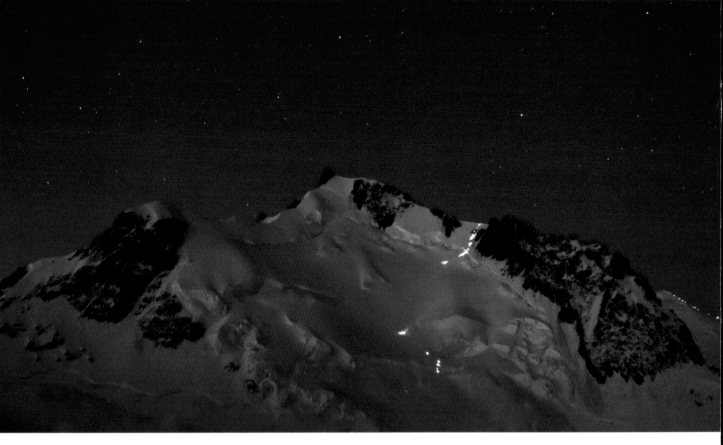

By now, you should have learned more than enough to create great images on your next mountain trip — or, perhaps I could say more accurately, you have enough material to help you get a serious start on your own path toward becoming a better photographer. The point of this chapter is to take things one step further and discuss some more advanced techniques, which, though far from essential, could prove useful and will be welcome additions to your photography toolbox. This chapter will only serve as a brief introduction to these techniques, however, and each of these topics deserves an entire book of its own.

▲ *In this photograph, I didn't use a tripod. Instead, I simply put together a small snow platform that took me less than five seconds to build. (Climbers' headlamps on col du Mont Maudit and Arête des Bosses, on their way to the summit of Mont Blanc, Chamonix, France. August 2009.)*

Low Light and Night Photography

If the point of photography, as even its name suggests, is to record light, what do you do when the light disappears?

To compensate for the lack of light, you will need to modify the three variables of exposure: aperture, ISO, and shutter speed. Your first step is to fully open your aperture, but even with very fast optics, this technique will rarely be enough to obtain a proper exposure. This will also reduce your depth of field, an unfortunate side effect since low light means precise focusing will be much more difficult to achieve. Indeed, in extreme cases, the only way to obtain a reasonably sharp image is to close the aperture until the depth of field is so large that it includes your subject no matter where you actually focus.

Unless you are shooting film, your next step is to increase ISO, and with it, the noise level. In this case, equipment does make a real difference, as the modern, large-sensor cameras will be able to use very high ISOs before noise reaches an unacceptable level. A compact camera may show a worse image at ISO 400 than a top-of-the-line DSLR at ISO 12,800! You should also have a good understanding of noise reduction: removing chroma and luminance noise is fairly easy, but the hard part is leaving the details and textures intact. Most cameras will apply heavy-handed noise reduction in their JPEG processing, resulting in a

▲ *Sunrise on the southwest ridge of Nevado Chopicalqui, Cordillera Blanca, Peru. June 2009.*

plastic look on all the surfaces in the image, which is especially disturbing on human skin. Of course, in-camera noise reduction is irrelevant when shooting in RAW file format, though you will still see it applied to the LCD screen preview. You should already have a fairly good idea of what your camera's maximum acceptable ISO level is, though you can always go further in emergency situations: content always trumps technical flaws.

With ISO at its maximal acceptable level and aperture fully open, your last hope to obtain a proper exposure comes from slower shutter speeds. Unfortunately, even with powerful stabilized lenses, you will still be shooting well below the handheld

threshold. If you are not perfectly stable, you will get blurry results, which generally means you will need to use a tripod. Even if you are courageous enough to bring one on your expedition, you should still be very careful if you want your images to be of optimal quality. Since the tripod will probably be lightweight, it will easily transmit vibrations from the ground and be moved by the wind. Weighing it down, for instance with a hook below the central column, will often be necessary. You should always use a ball head adapted to the weight of your equipment and carefully tightened. Mirror lock-up (MLU) and remote triggering functions—activated by either an infrared remote or a simple self-timer—will be crucial in avoiding the vibrations caused by the mirror slapping up or your finger pushing the whole camera downward.

Though it does make things more difficult, not having a tripod does not necessarily mean you cannot photograph low light and night scenes; it is almost always possible to find a makeshift platform of some sort. Look for a hard and flat surface: a boulder or compacted snow, for instance, but definitely do not use a backpack or a tent floor. Using careful techniques and understanding some of the more advanced features of your camera, especially MLU and the self-timer, will be even more important than before.

▲ Ben Coe tightening his laces on the approach to the north face of Ben Nevis, Scotland. March 2010.

Of course, long exposure times will only work with relatively static subjects. Perhaps surprisingly, the sky is not static at all, and the stars and the moon actually move quite fast. (The only reason we cannot perceive the swift motion of the moon and stars is because we do not have a point of reference.) As a rule of thumb, any exposure longer than 30 seconds will result in a blurry moon. To compensate for this movement, you will need to use equipment dedicated to the task. However, proper astronomy photography technique is largely outside the scope of this book. Headlamps can be very interesting elements in

photographs with long exposures. Since they are so much brighter than the rest of the image, they will only need a fraction of a second to record, and if they move around, their trails will look like surreal bright lines. With some talent and a bit of practice, you can even write or draw with them, but the most interesting images certainly are the ones showing the progression of night climbers on the mountain. For similar reasons, a tent filled with people using artificial lights will appear to glow against the night sky.

Apart from the situations already discussed, two other important parameters are also affected by low light: metering and focus. Matrix or center-weighted meters treat day and night photographs in the same way: they attempt to average exposures throughout the image to 18% gray, even though you may actually want large parts of the image to be very dark. The two possible ways to work around this issue are either to go back to full manual mode and shoot test images until an acceptable exposure has been obtained or to use a spot meter on the brightest part of the subject.

The autofocus feature can only do so much when contrast is very low, especially when using slow lenses, and at times, it simply gives up. You probably won't get much better results by focusing manually, so a large depth of field and the distance scale on your lens will become your most important tools.

You should systematically review images on the LCD screen until the focus is perfect.

Sometimes, you can use a flash instead of taking very long exposures. Strobes can be especially effective when used as fill-light on a foreground subject, while the background stays lit naturally. Using this kind of lighting has severe limitations, though, and the pop-up flash found on most cameras (including expensive DSLRs) rarely gives good results. To create interesting and unobtrusive lighting, flash needs to be used off-camera and either diffused or bounced. Since the equipment needed for this kind of shot is too heavy and cumbersome to be carried into the wild, I will not elaborate any further.

You should especially be mindful that many lenses focus past infinity: turning the focus ring all the way does not guarantee that you will capture sharp mountains, as I learned the hard way in Peru. I kept blaming the innocent rock platform and gave up on a lovely view of our camp under the stars after the fifth botched thirty-second exposure, only to discover this sad truth about my Sigma lens the next morning.

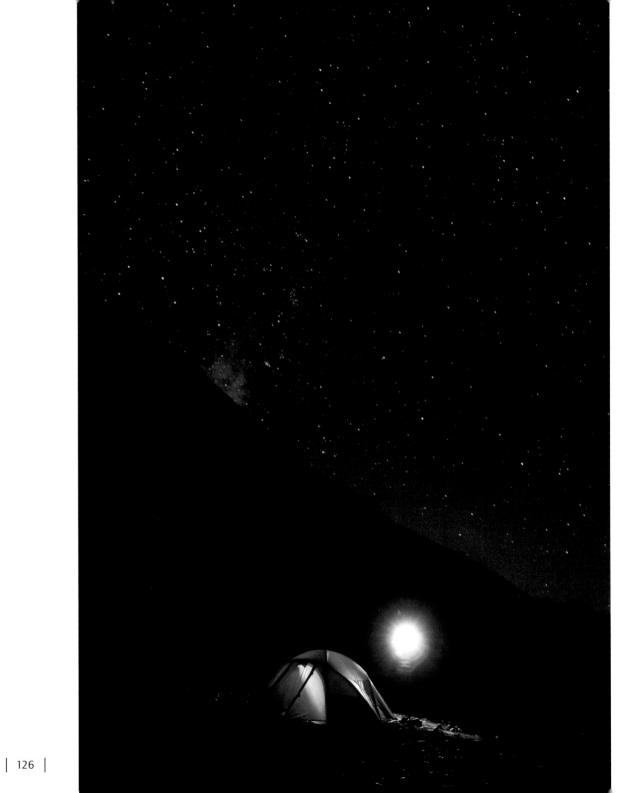

Panoramic Images

Panoramic images (images much longer in one dimension than the other) can give powerful and original representations of some locations (e.g., the unobstructed view from a summit). They also open the door to new possibilities for striking compositions.

An easy and straightforward way to create panoramics is simply to heavily crop a normal image, but this approach has some serious drawbacks: it drastically reduces resolution (since you are throwing away most of the pixels in the image) and it does not provide a wide enough angle of view. The alternative, stitching several images together, requires a lot more work, both at time of capture and in post-processing, but it also opens virtually unlimited possibilities, up to the completely immersive double 360° panorama. At superlative resolutions, this technique allows prints to routinely be several meters long!

To be done accurately, a stitched panorama requires much time and effort, as well as specific equipment, most notably a tripod and a panorama head. Shooting handheld, however, provides a lightweight alternative. If you are willing to practice stitching and correct minor artifacts in post-processing, you can produce excellent results. Be aware, though, that

◀ *The Milky Way above Island Peak base camp, Khumbu, Nepal. October 2010.*

geometrical accuracy is not guaranteed, especially near the edges, a fact that could be an issue for architectural work (an uncommon occurrence in the wild) or if you are relying on the image being to scale.

As always, your first step should be to ask yourself whether a panorama is really the best way to represent the scene in front of you. You need to take into consideration that stitching a panorama will take a lot of work when you are back at home and that there needs to be interesting subject matter along the length of the whole image. If you are going for the full 360° view, ask yourself the following questions: Is the view at your back as interesting as the one in front? Can you see up and down in all directions? Above all, remember that your image should be interesting because of what it shows, not because of its fancy dimensions!

Next, you should select a focal length. Since you will not be using a tripod and a panorama head, you will lose a lot of pixels in the stitching process. You should also take into consideration that your images will need to significantly overlap each other for the stitching to work properly. This means that you will need a wide angle of view, something like 18 mm, which would require about 18 images for a 360° view. (The alternative to using a wide angle of view would be to make several passes and stitch vertically as

▲ *360° panorama from Punta Union pass, the highest point of the Santa Cruz trek, Cordillera Blanca, Peru. June 2009.*

well as horizontally, but this technique is even more advanced and should be reserved for truly desperate cases.) Without shooting anything, use your camera to do a quick pan of the scene to check whether it will be entirely contained in your frames, allowing for generous margins of error. If the top of a peak appears too close to the edge, select a wider angle or pears too close to the edge, select a wider angle or

view or flip from horizontal to vertical framing.

Choosing the right exposure can be a difficult task. You have two alternatives: If the difference in luminosity between the darkest and the brightest part of the image is not too wide, chances are that your stitching software will be able to automatically adjust the exposure between frames, which means

you can shoot in aperture priority mode and obtain the same average brightness everywhere. If, however, the exposure in each frame varies too much, for instance, if the sun is close to the horizon in one direction, then modifying the shutter speed between frames will result in an ugly zebra look in the stitched final image, with alternating bands of bright and dark skies instead of a continuous gradient. The solution to this problem is to use manual exposure; fixing both the aperture and shutter speed on your camera, and you must decide which average brightness is acceptable throughout the entire panorama. Of course, you will probably have some blown highlights and lost shadows. Take a few test shots in both the brightest and darkest parts of the scene to check your exposure.

▲ *360° panorama from the summit of Stob Coire nan Lochan, Glencoe, Scotland. April 2010.*

Having decided on framing, focal length, and exposure, you are now ready to shoot. You will want to take all the pictures in as short a time as possible, since varying conditions (moving clouds or people) will greatly reduce the quality of the stitching. While being as stable as possible, frame, shoot, and rotate your torso a few degrees without moving your feet. Once you are completely turned to one side, move both feet about 120° and repeat the process until you have taken all the photos you need. Make sure you do not rotate too much between shots and overlap at least 30% of the image or, ideally, 50% of each image. This means that the right edge of the first image should be in the middle of second image and on the left edge of the third image. Also, try to remain steadily horizontal between frames. Even if the buf-

fer of your camera can't empty fast enough and you have to wait a few seconds in the middle of the shoot without being able to take a picture, don't take the camera away from your eye, as finding the exact same framing would be difficult. Similarly, don't review the images on your LCD screen until you are finished with the entire series of shots.

Once you are done, you can relax and review your images, checking both sharpness and exposure. If a frame seems unusable, it is best to delete the whole batch and repeat the entire process. Although, you can sometimes get away with reshooting a single image if conditions haven't changed too much, if people have moved significantly between frames, you will probably want to start from scratch; otherwise, you will have ugly ghosting on the final image.

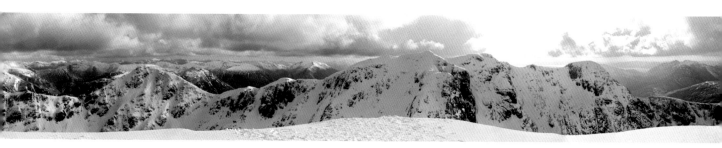

The second part of making a panorama is the stitching itself, which takes place on your computer when you are back home. Many software programs can perform this task for you, including the latest versions of Photoshop, but be aware that most are designed for very accurate shots using dedicated panorama heads and tripods, and they won't gracefully handle the small differences between each handheld shot. I suggest using software that allows you a large amount of manual control over the stitching process. As of right now, the best option seems to be AutoPano Pro, which helped create all the panoramas in this book.

Since the fine-tuning of the stitching process is so heavily dependent on which particular software you end up using, I will not discuss stitching and post-processing in depth, but I will mention a few general points. One consequence of shooting handheld is that, in an effort to correct small variations between each frame, the software will modify the geometry of the scene, sometimes resulting in bent horizons or tilted vertical lines. These aberrations are usually not too much of an issue with natural scenes, where perfectly horizontal or vertical lines are rare anyway, but you should still look for any element that appears obviously wrong, either in orientation or in proportion. You should also be on the lookout for stitching artifacts, which are most often continuous lines from one frame to the next that end up being cut off—unfortunately a common occurrence near the edges of each image. Such artifacts can be hard to spot (though you can be certain that it will be the first thing any viewer will notice), and examining the image at a 100% view is often time well spent. Most artifacts are usually easy to fix with careful cloning, which most reasonable people would consider fair game, since you are doing nothing worse than what stitching software does.

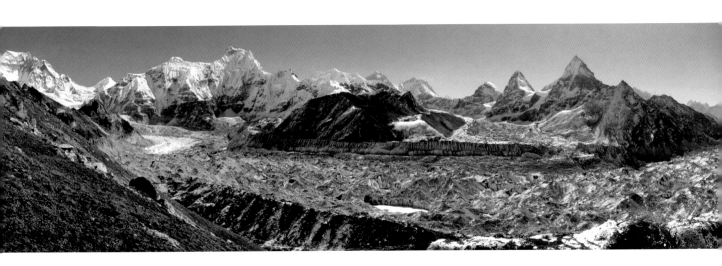

▲ *Panorama from above Ngozumba Tsho, the fifth Gokyo lake. Three of the world's five highest mountains can be seen: Everest, Lhotse, and Makalu. Khumbu, Nepal. October 2010.*

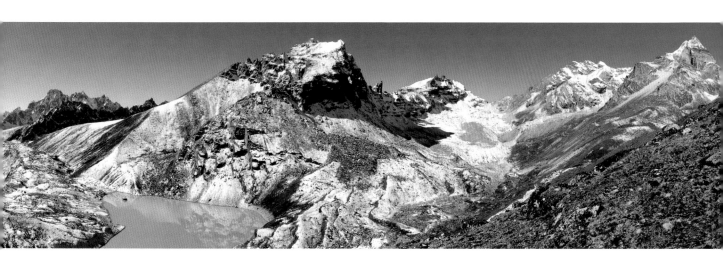

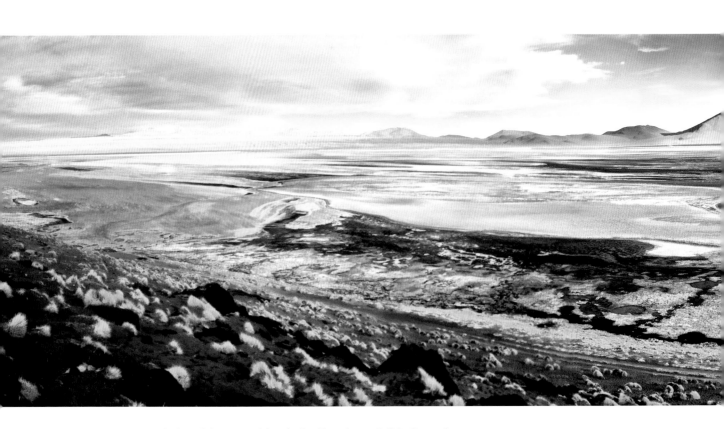

▲ *Panoramic view of the Laguna Colorada, Sur Lipez desert, Bolivia. September 2007.*

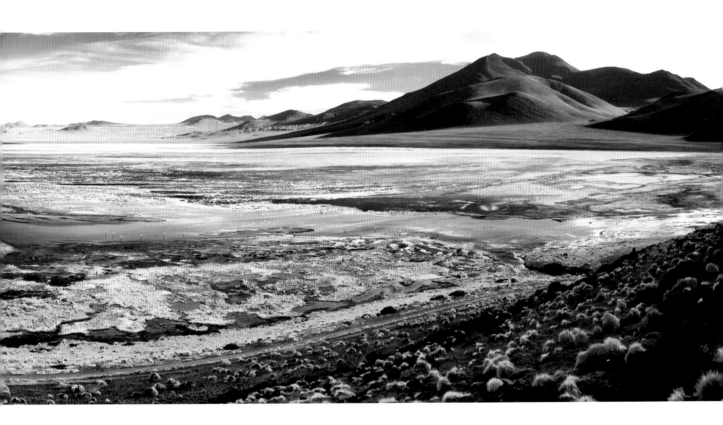

HDR

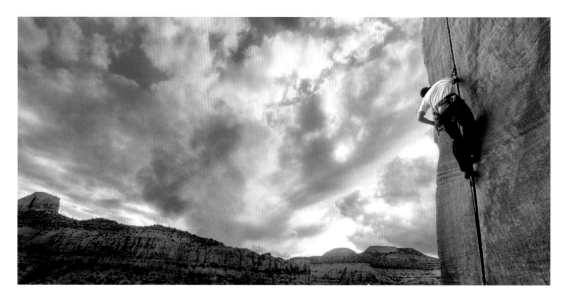

▲ *Sonnie Trotter on Air Swedin (5.13 R), Indian Creek, Utah. October 2009.*

HDR stands for High Dynamic Range imaging and refers to a technique used when the contrast of a scene exceeds what the sensor of a camera can record. It works by merging several exposures of the same scene, allowing you to conserve details in both highlights and shadows. This is the official definition, but HDR is also often used to describe a specific look that has become very popular with certain Internet crowds; an image that looks almost like a painting, exhibiting extreme levels of saturation and local contrast. (To be precise, these images shouldn't even be called HDR. A more fitting term would be tonemapped, after one of the steps of the HDR image generation process.) Because of this confusion, and because it is relatively difficult to avoid the artificial look, HDR tends to be a pretty sensitive subject that many photographers love to hate. However, if used with care, it can be a very powerful tool and is sometimes the only way to accurately record a scene.

Like panorama stitching, HDR is a two-phase process

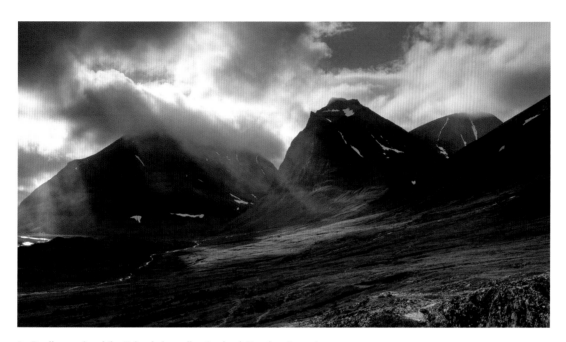

▲ *Duolbagorni and the Kebnekaise valley, Lapland, Sweden. August 2007.*

that relies on multiple captures and dedicated software in the post-processing phase. Here as well, you have a choice between getting the best accuracy with a tripod or accepting some compromises and shooting handheld. Hikers and climbers will naturally prefer the latter.

Assuming that you are using HDR purely in order to reduce contrast, you can easily determine whether a scene requires its use: take a test shot and examine the histogram. If it is cut off at both ends (i.e., if the histogram shows both blown highlights and lost shadows), then the dynamic range of the scene exceeds what your sensor can record. If only one end of the histogram is problematic, try adjusting exposure compensation until you either have an adequate capture (the histogram is entirely contained within the

boundaries) or you are showing the dreaded double cutoff. You should also keep in mind that moving objects are even more problematic to the HDR process than they are to the taking of panoramas. Sometimes, with careful cloning, photographers can get rid of the ghosting artifacts that moving objects generate, but it requires a lot of post-processing effort, and the results are often less than perfect.

For HDR to work, you need to take a series of exposures showing details in both shadows and highlights. Most cameras have an auto-bracketing feature to help change settings automatically between shots, and it should be set to the foolproof settings of 3 frames at +/−2 stops, on aperture priority. This setting will be enough for almost all scenes you are likely to encounter, and because you are only modifying shutter speed, your depth of field will not vary. Since there will inevitably be tiny movements between each shot, the HDR software will align and crop the images in post-processing, removing a few pixels on the edges. To account for this, frame a little wider, incorporating a margin around your ideal final image. Finally, set your camera to burst mode so you don't have to press the shutter several times.

Once you are ready, simply shoot your three frames in quick succession, and then review your images, checking that the histogram of your under-exposed image is not cutoff on the right side, and, conversely, that the overexposed one is not cutoff on the left side. Finally, verify that the sharpness of the overexposed image is satisfactory, since it will have been taken with a much slower shutter speed than the other two images.

Once home, you can start the delicate process of merging all three images into a single frame. Though the latest versions of Photoshop now have this capability, you will obtain the best results with software specifically designed for HDR bracketing, such as Photomatix Pro or qtpfsgui. After aligning and merging the images, the crucial, final step is called *tone-mapping*, and this is where the magic happens. If you are careless, or if you use the default settings on your software, you will probably end up with a grossly unrealistic image. Obtaining believable results takes practice, but the key is to use the HDR software very conservatively: only recover details in shadows and highlights and keep contrast and saturation very low. You will set brightness, contrast, and saturation to your ideal values for each separate zone of the image at the very end of your post-processing, in a traditional imaging program such as Photoshop, by using curves and layer masks.

One alternative to using automated programs is to manually create layer masks to locally apply the

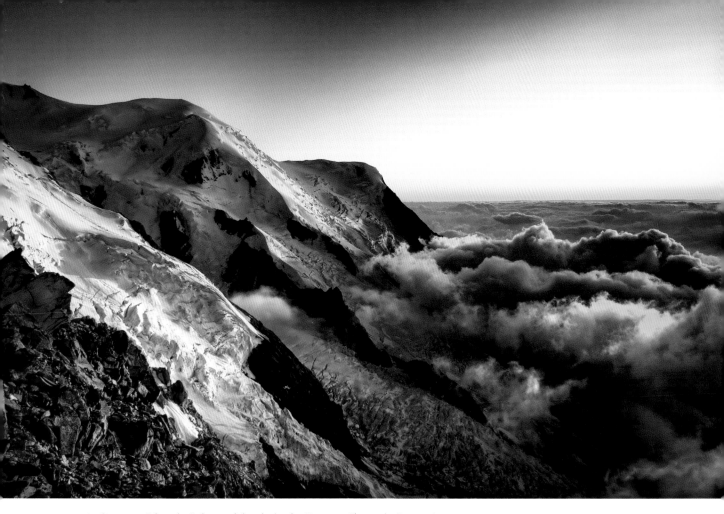

▲ *Sunset on Dôme du Goûter and the glacier des Bossons, Chamonix, France. August 2009.*

different brightness levels. While this technique usually produces the most believable results, it is also usually a very time-consuming and frustrating task to paint a convincing mask.

You could easily go overboard with HDR, but if you try to be honest and match your memory of the scene, your image will look more realistic. A good way to test your memory is to let the image rest for a few days, and then come back to it later with fresh eyes. Or you could ask for someone's honest opinion. What is their first reaction to the image? "This is beautiful" is a good response, whereas "This is Photoshopped" isn't.

Video

Some may argue that video is an entirely different medium from photography and has no place in a book such as this one. However, new developments in DSLRs have changed the game, and nearly all models now possess HD video capabilities. Since large sensors and good lenses now allow us to obtain near-professional high-quality video footage with equipment that we are carrying already, we should take advantage of this opportunity to explore a new medium.

You should exercise great caution when shooting video: if anything is worse than enduring someone else's slideshow of 500 photos, it would be enduring two and a half hours of wobbly, poorly framed video footage from the same trip. Don't bother with getting motion footage unless you plan on taking the time to edit it into a small movie when you get back home, as video editing usually requires significant effort and has a steep learning curve.

Storytelling is very different in video than in still photography. Indeed, an entirely new language needs to be mastered. Whereas a photo captures a single instant in time and uses suggestion, relying on the imagination of the viewer to build a convincing story, a film is by essence much more explicit and has to actually *show* what is happening.

The only reasonable way for you to construct a compelling film is with careful planning. Try to work out in advance what message you want the film to portray, and then think about what footage you will need to relay your ideas. A coherent narrative is much harder to construct from random clips captured at your convenience.

Most amateur outdoor videos found online use very long single shot sequences, often lasting several minutes, which is long enough to bore even the keenest viewer. Though this technique does require a lot more effort, instead, try constructing sequences with the age-old recipe of five different shots, each one lasting between 2 and 10 seconds. Following are some suggestions for content:

- **A closeup of a face** – creates an emotional connection with the subject. Be sure to show both of the subject's eyes and avoid underexposing too much. Also, try to throw the background out of focus with shallow depth of field.
- **A mid-range shot** – gives a clear view of the action. This framing technique is the one that you use naturally, but it quickly becomes boring if used too much.
- **A closeup of the hands** – involves the viewer with whatever action is being performed and creates variety from the mid-range shots.

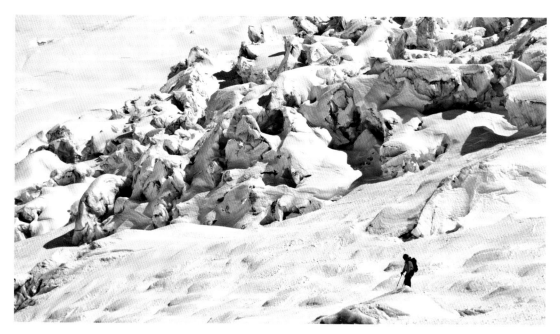

▲ *Skier next to the Séracs du Geant, Vallée Blanche, Chamonix, France. April 2009.*

- **A point-of-view shot** – shows the action as if it were being performed by the viewer himself. A fun way to obtain this footage is by affixing the camera to your helmet, or you could simply shoot over the shoulder of your subject.

- **Get creative** – and surprise the viewer with something unique or unusual. For instance, you could shoot *through* some other object, use defocus to blur the subject, try focus pulling, frame a very wide shot of the location, provide a view from the ground, etc. The possibilities are endless.

Also, think carefully about your composition and make good use of the rules in chapter 3 under "Composition". In particular, position the horizon and your subjects 1/3 of the way from the edge of the image, never in the center. Leaving space in the frame for your subject to move into is an even more important point in motion video than in stills, since the subject can literally move out of the frame!

On the technical side, most video-enabled DSLRs and EVIL cameras will shoot at least a decent 720p (which is preferred over 1080i for action), but only a few cameras allow the crucial manual control of shutter speed and aperture, relying instead on auto-exposure and ugly adjustments whenever you move from shade to brightness. Autofocus on today's cameras is continually improving, but if you decide to use it, remember to revert to manual focusing as soon as your depth of field narrows down. Similarly, zooming is a very difficult function to use without inducing copious amounts of camera shake, but this inadequacy may be a blessing in disguise, discouraging us from employing what may be the most overused effect in the entire history of moving pictures.

Sound should never be underestimated, and it is often more important than the video itself in building a good story and engaging the viewer. Unfortunately, video DSLRs rarely produce satisfactory sound be-

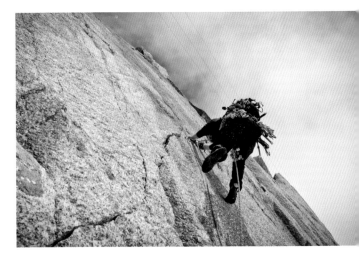

▲ *James Monypenny on the first pitch of the Rébuffat route (V+, 120m), Éperon des Cosmiques, Chamonix, France. June 2010.*

cause the built-in microphones are woefully inadequate, and sound input (not to mention sound monitoring) is often missing altogether. Since no camera is likely to have the professional XLR inputs, you have two basic choices for capturing decent sound: either use a portable microphone on the hot shoe and plug it into the mini-jack input if your camera has one, or use a separate audio recorder and sync the sound in post-processing—a time-consuming and often difficult task. Though sound add-ons are expensive and inconvenient to use, you need to use them if you are even remotely serious about your movie.

Finally, take it easy on the effects. Focus pulling, zooming, tilt-shifting, using slow-motion, recording time lapses, etc. are great ways to enhance a story, but they should never become the subject of your film or try to hide the fact that your footage is poor (Hollywood directors, take note).

Note: You can find books on many of these top-ics in the Rocky Nook collection, such as The HDRI Handbook, Mastering HD Video with Your DSLR, Practical HDRI 2nd Edition, Photographic Multishot Techniques, Digital Astrophotography, Mastering Digital Panoramic Photography, *and many more.*

▶ *Silhouette on the Uyuni salt flats, Bolivia. September 2007.*

▶ ▶ *Next page, left side: Early morning frost above Dingboche, with the south face of Lhotse in the back-ground, Khumbu, Nepal. October 2010.*

▶ ▶ *Next page, right side: Porters carrying loads of equipment down from Lobuje East High Camp, Khumbu, Nepal. November 2010.*

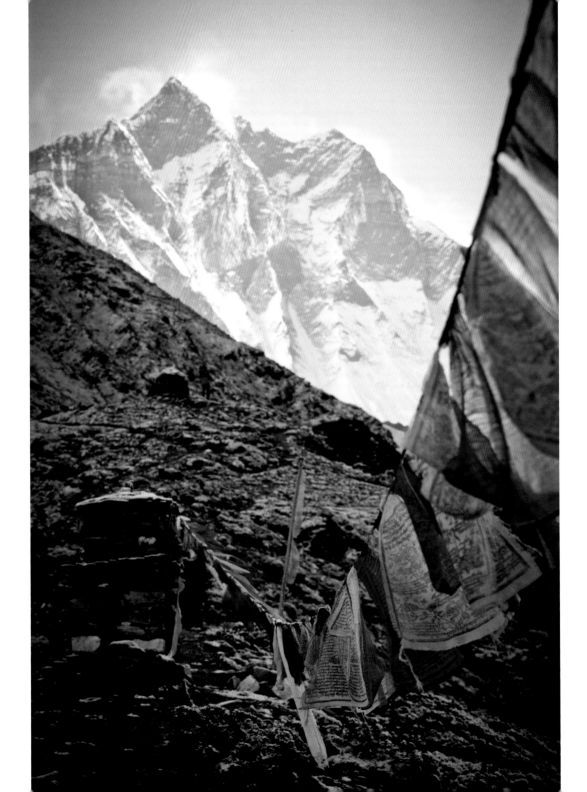

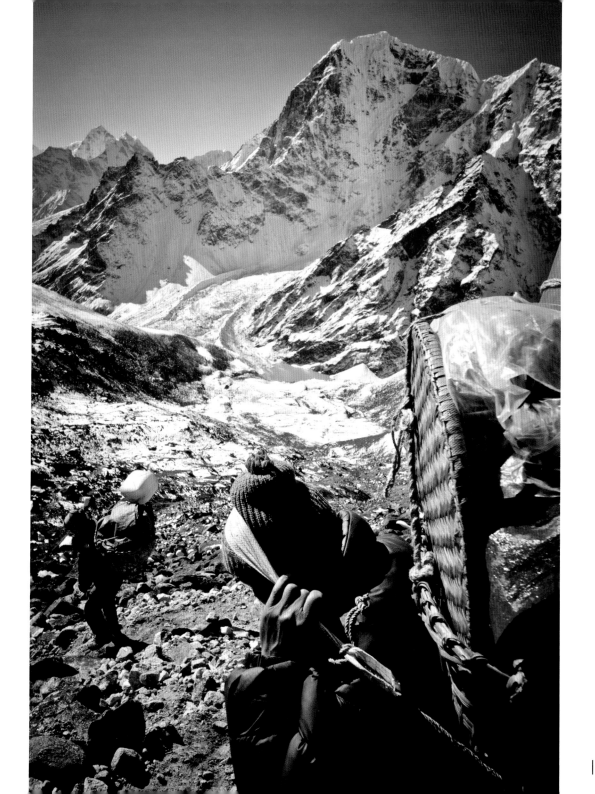

Closing Thoughts

Chapter 6

Ethics and Photo Manipulations

We still need to address some important points. Though we discussed at length the nuts and bolts of photography in the mountains, there are a still a few more things that every photographer should always keep in mind.

In 1971, the legendary mountaineer Reinhold Messner published a famous article, "The Murder of the Impossible," which argues that technological advances in climbing equipment, in particular expansion bolts, "murdered the impossible" and allowed any wall to be beaten into submission. This article led to a heated debate, still ongoing, about which climbing practices are acceptable and which should be considered cheating.

The situation in photography is strikingly similar, and ethics are even more important to photographers than ever before. Though photo manipulations have always been possible to do in the darkroom, the digital revolution has made the process quick and easy. You can remove offending telephone wires or even climbing ropes in mere seconds, and with sufficient time and effort, you can doctor any image beyond recognition. If you browse the web, you can easily find lively discussions centered on whether or not photo doctoring is a good thing and on where the line should be drawn.

First, let's define exactly what we are discussing. There are two broad classes of manipulations that shouldn't be confused: minor modifications and scene-changing modifications. On one hand, minor modifications to images, such as fine-tuning brightness, adjusting colors, sharpening, and even cropping, can be seen as merely addressing the limitations of the camera. Automated JPEG processing performs similar modifications inside the camera. Unmanipulated images are a physical impossibility: The only question is who should do the manipulation, the user or the camera. On the other hand, some manipulations can be described as scene-altering. These modifications range from outright photo montages to cloning, from excessive contrast and saturation modifications to surreal-looking tonemapping.

An interesting process that highlights the differences between these two types of manipulations is HDR. As we saw in chapter 3, HDR can be used to extend the limited dynamic range of the camera sensor and to produce an image that comes closer to what our eyes and brain see at the actual scene. But through excessive tonemapping, HDR can also create overly-contrasty, oversaturated pictures that no one could ever witness with the naked eye (at least, not without the help of controlled substances).

I certainly don't pretend to have a definitive answer to such a highly personal subject: you must decide which manipulations are acceptable for your photography. But I would simply like to make one observation: whatever you decide is acceptable, you should be honest about your choices. This advice is doubly important in regard to nature and action photography, as there is an implicit contract with the viewer that the image represents what she would have seen had she been next to you at the time of capture. No matter how you look at it, breaking this trust, (for instance, by copying the full moon above the vista from another image) in my opinion is morally wrong. Cloning out the ugly telephone wire can be okay, but you owe it to your viewers to mention the deletion somewhere.

▶ *I wasn't sure if I should include this image in the book. I originally thought the photo was ruined because my own shadow fell into the frame and on the left wall, a situation that was impossible to avoid at that time of day. With some work, I managed to remove the shadow in Photoshop, and now I mention this alteration whenever I show the image. You can decide for yourself if it's cheating or not. (Andy Turner on Incredible Hand Crack (5.10), Indian Creek, Utah. October 2009.)*

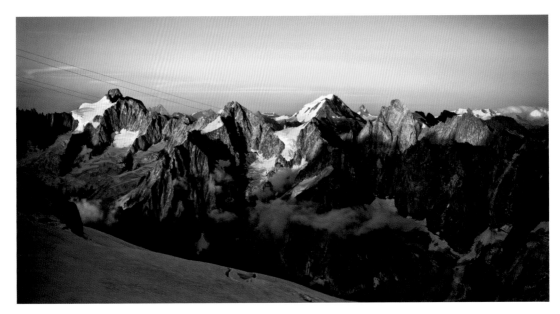

▲ *This image could be so much better without the cable car lines, but this is what you see when you are there. (Sunset view across the glacier du Geant, Chamonix, France. August 2009.)*

In addition to this crucial issue of honesty, my personal position is that any manipulation is acceptable as long as its goal is to more closely align the image with my personal memory of a scene, taking into account how a scene made me feel. This means that I will occasionally exaggerate some aspect of an image, (e.g., I may make the storm clouds on the horizon appear more threatening) to better communicate my message. I concede that these types of photo manipulations are subjective, but I am fine with this classification since my goal is to create "art," not an objective record.

In short, there is no easy, pre-digested answer to this issue, and you must carefully think through the pros and cons to reach your own conclusion.

▶ *The sherpa capital, Namche, Khumbu, Nepal. October 2010.*

Chapter 6 – Closing Thoughts

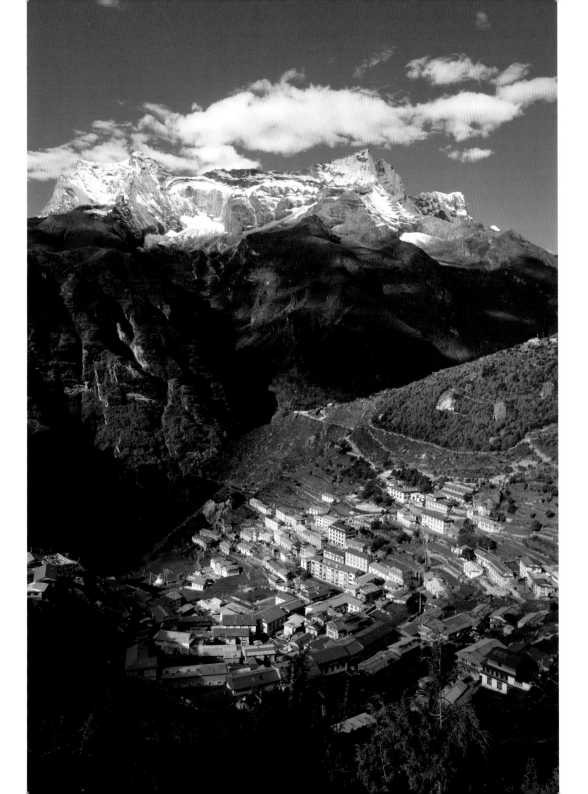

Safety and the Environment

I cannot emphasize enough that mountains, and wilderness areas in general, are very dangerous environments. People frequently get hurt, or even die, in the wilderness, and if you believe that such accidents only happen to others, you are setting yourself up for disastrous disappointment later.

This next point is extremely important: disregard any advice provided in this book as soon as it starts interfering with your safety or the safety of others. Remember to always get your priorities straight: no photograph (and no summit) is worth getting hurt for!

In order to achieve some level of safety in the mountains, speed is often crucial, allowing you to escape from nightfall, bad weather, cold, and avalanche or rock-fall danger. This urgency sometimes means that you need to sacrifice photography, as it would slow you down too much, and you should always make that choice without hesitation or regret. As the saying goes, the mountain will still be there the next day. Make sure you are too.

In order to be safe when climbing, you have to be in control. If you are too close to the limits of your technical, mental, or physical abilities, the extra constraints and strain placed upon you from photography could be what pushes you over the edge. Mountains can be extremely unforgiving, and a small mistake is often all it takes for a disaster to happen.

You should seek proper instruction before venturing into wildnerness areas, and always bring adequate equipment—not only for what you plan to happen, but also for what might happen. You should never be caught by bad weather on a hike without a rain jacket, just like you should never cross a glacier unroped or without making sure all members of the party have learned crevasse rescue. Hiring a guide or taking wilderness or mountaineering courses is crucial: most of the skills you need to survive simply can't be improvised on the spot!

▶ *Midway loch on the pony track to Ben Nevis, Scotland. May 2008.*

Back in 2009, I was in the climbing mecca of Indian Creek in south-eastern Utah, and I decided to take pictures of British climber Andy Turner on the ultra-classic Incredible Hand Crack. A rope was fixed from the top of the pitch, and I was given aiders and handled ascenders. Up to that point, I had only used prusik knots to ascend a rope, but I felt safe: the wall was only 65 feet high and some of the world's best climbers were around—what could possibly go wrong? I ascended and took some good photos (including the one of Andy ealier in this chapter) but I soon realized my mistake: I hadn't taken enough gear with me to rappel down, and I didn't know how to jug down. Furthermore, the top of the pitch was bulging, and Andy's rope was rubbing across mine— not a big deal for him because his point of friction kept changing as he was being lowered, but my rope was fixed, and the high temperatures could have potentially melted the nylon, cutting my rope entirely. Luckily, that didn't happen, and the climbers below found a way to rescue me from the top, but things could easily have turned out differently. I was too complacent and relaxed, and I could have paid dearly for that mistake. Don't learn such lessons the hard way!

Finally, I should mention that the reason we choose to head into the wilderness is because there is some wilderness left for us to enjoy. Therefore, it is absolutely unacceptable to leave any kind of waste or to do any irreparable damage to the environments we visit. Do study the Leave No Trace philosophy (www.lnt.org) before leaving. Also, research the local regulations and ethics of the places you are visiting and always respect the flora and fauna in those areas.

As photographers, we have a unique opportunity to document the terrible ecological damage inflicted on virtually every single ecosystem on the planet, but we also have a responsibility to exhibit exemplary behavior, showing that it is possible to enjoy the wilderness without destroying it.

▶ *Rope team on the Mendenhall glacier, Juneau, Alaska. August 2008.*

▶ ▶ *Next page: High winds blowing snow off the summit of Cholatse, Khumbu, Nepal. November 2010.*

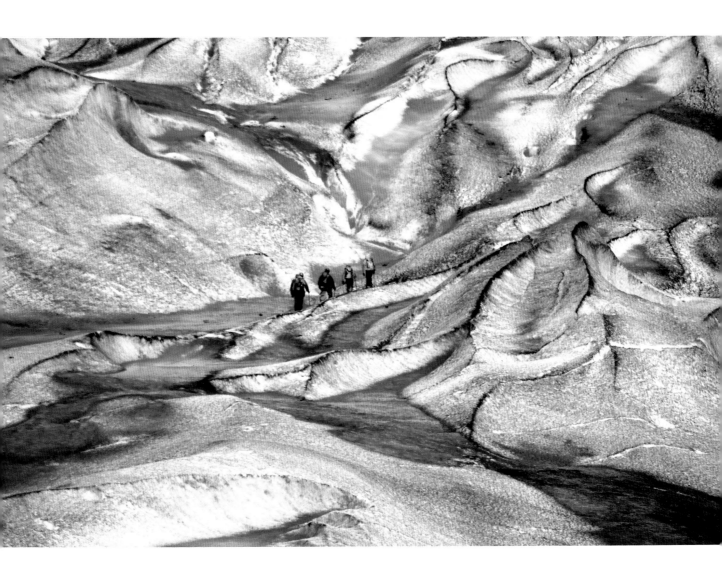

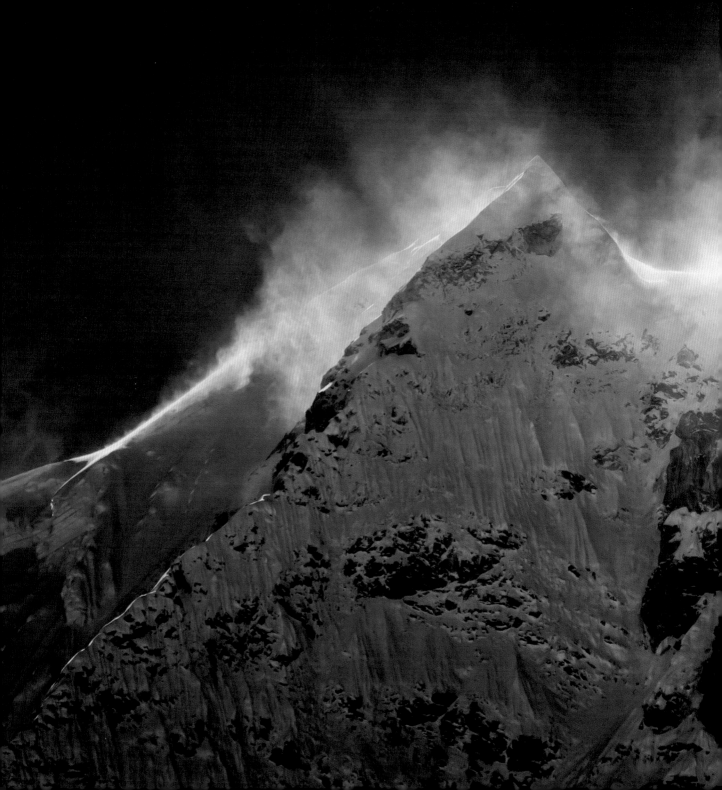

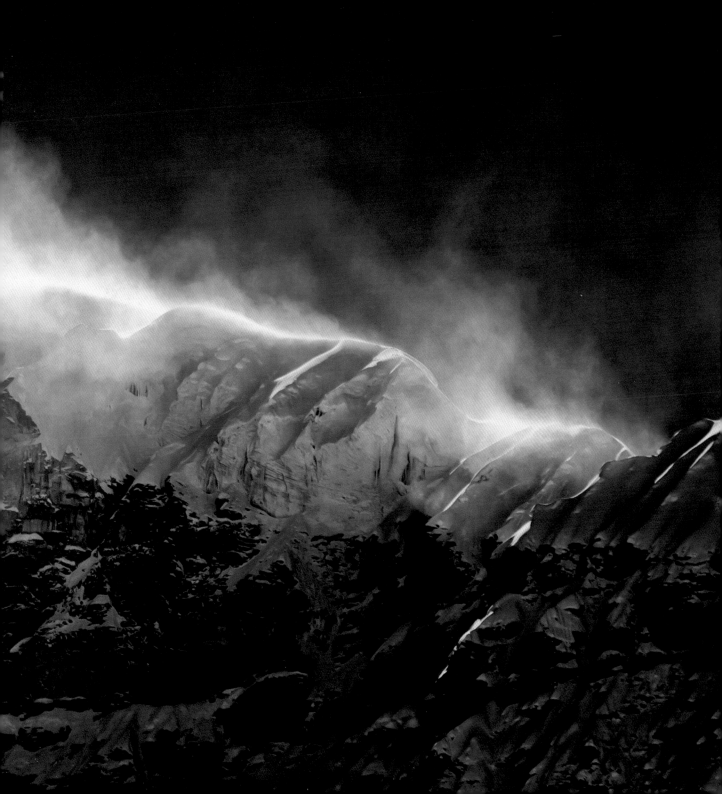